LOST
FOLKESTONE

ALAN F. TAYLOR

AMBERLEY

I dedicate this book to Richard and Pam Taylor

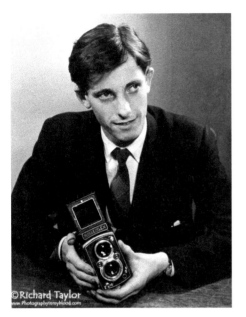

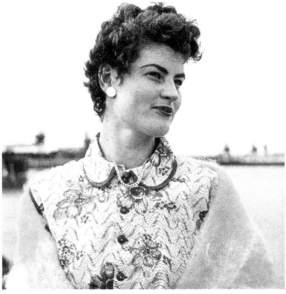

First published 2020

Amberley Publishing
The Hill, Stroud
Gloucestershire, GL5 4EP

www.amberley-books.com

British Library Cataloguing in Publication Data.

A catalogue record for this book is available from the British Library.

ISBN 978 1 4456 9543 3 (print)
ISBN 978 1 4456 9544 0 (ebook)

Origination by Amberley Publishing.
Printed in the UK.

VIEWS OF FOLKESTONE
AND THE NEIGHBOURHOOD

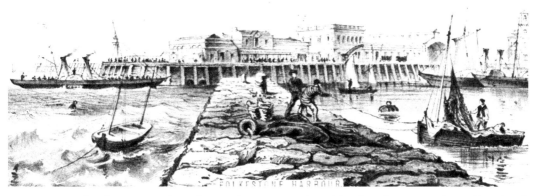

A view of Folkestone Harbour from Nelson's pictorial guidebook *Folkestone and Neighbourhood*. Published in the 1870s, it is printed in an early form of coloured printing called chromolithography. It shows an early paddle steamer entering the outer harbour, the bonded stores, Custom House (built in 1859), and the first harbour station.

This calendar for 1878 was produced for W. Strood, tea dealer and grocer. He had shops in Harbour Street, Dover Street and Dover Road. The portrait is of HRM Princess of Wales, who became Queen Alexandra, Edward VII's wife.

Introduction

I was born in Folkestone just before the Second World War and brought up in the town – apart from the war years – when in late 1939 or early in 1940, my mother, sister Marion, and I went to stay with a great aunt at Ludwell, Dorset, for a few months before moving to Tunbridge where we stayed until the end of the European war, late in April 1945.

I have vivid memories of the devastation caused by the shelling and bombing during the war. It changed the face of many streets such as Harbour Street, Beach Street, North Street, Dover Street (Harbour Way), Rossendale Road and Dover Road, so I have seen many changes down the years, and needless to say they are not all for the better!

I have very fond memories of the Warren. My parents started camping down there in 1930, and when my sister and I came along, we spent our weekends and holidays camping until the war came. We resumed camping after the war in 1946 after the mines had been cleared. We would pitch our tents around the spring bank holiday and would leave them up until the end of August. My parents camped until 1960, at which time one tent was burnt down by vandals and items were stolen from other tents – a sign of the times.

Over a hundred old photographs and engravings are taken from my collection, showing many places and buildings in Folkestone in times gone by. I have included a number of engravings dating back to the 1870s from Nelson's pictorial guide *Folkestone and Neighbourhood*. They are purple-tinted views, an early form of coloured printing called chromolithography – a unique method for making multicolour prints. I have also included images from stereo cards, which are an early form of 3D.

I am fortunate to have access to many of the black and white images used in this book from the negative archive belonging to Richard Taylor, who runs Nick & Trick, Services Photographiques at No. 63 The Old High Street.

Richard James Taylor was born in Folkestone in 1965, son of one of the most renowned and busiest professional photographers in Folkestone and the surrounding areas during the 1950s and 1960s. His parents later revived and continued that work into the mid-1990s.

Richard and Pam Taylor were time served professional photographers who earned that title from a seven-year apprenticeship served with local studio Hawksworth Wheeler. An apprenticeship was required in order to be a pro at that time.

Richard (junior) grew up with photography and learned to fully appreciate its historical, social and artistic qualities through his own love and his parents' skills.

In recent years he has accepted that folk around might actually be right, and has come back to his love of photography outside of the years he spent as a photojournalist within British motor sport.

Returning to his roots, he is devoted to the use of traditional techniques in the use of various and sometimes specialist films, but also making use of classic equipment. It is his desire for this to be reflected in his works, and that he keeps faith with the family's own style.

He continues to piece together the things he learned from his mum and dad and is endeavouring to fill in the gaps that remain in their unfortunate absence. He hopes that people still remember who they are, and from that, who he is.

Following his father's untimely death in 2007, the family's negative archive of some 7,000 images that date to 1958 has come into Richard's possession. He continues to catalogue and make this work available, as well as understanding his own work.

The reader is requested not to copy photographs from this book to respect Richard's inheritance.

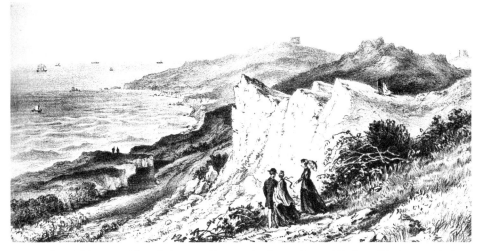

Extract from Nelson's guide: 'We leave Folkestone by Dover Street (Harbour Way), cross Radnor Bridge, and proceed along the edge of the cliff to Copt Point, the western boundary of East Wear Bay, where a notable example rises from beneath the gault, and the line of junction of the two beds is very distinctly marked.'

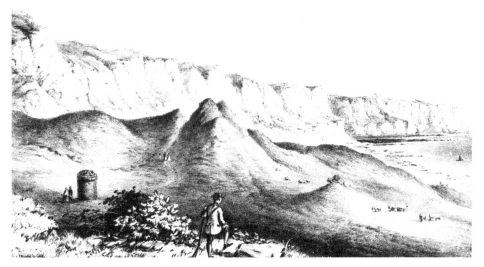

Extract from Nelson's guide: 'From this point we follow the cliff path for three or four miles, enjoying a glorious "marine view," and frequent glimpses of inland scenes, very bright and fair. At length we arrive at the so-called Shakespeare's Cliff.' It's interesting to note that the structure to the left-hand side of the man is a vent from the Martello railway tunnel.

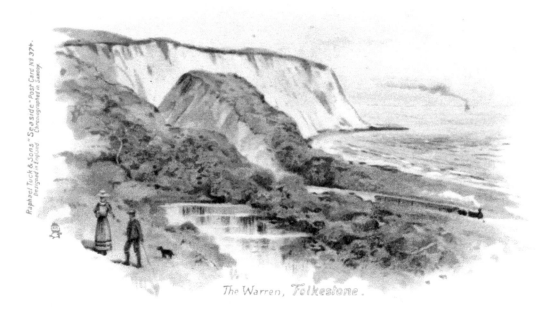

The Warren, Folkestone.

A chronograph (issued as a postcard in *c.* 1900) showing the Warren Rakemere Pond and a train from Dover heading towards Folkestone between Abbott's Cliff tunnel and Martello tunnel. The Warren is noted for its fauna and flora. A reference from *Rambles or a Naturalist Round Folkestone Etc.* by H. Ullyett BSc states: 'About 700 species of plants and the same number of species of Lepidoptera are found in the Warren.'

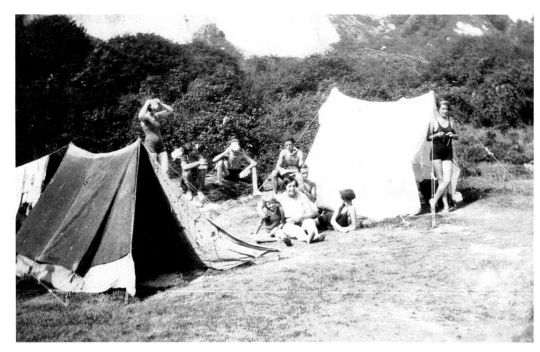

My parents started camping in the Warren with friends in 1930. Seen here are some of their tents. The lady on the right-hand side of the photo standing outside the tent is my late mother Rosie (Tess) Taylor.

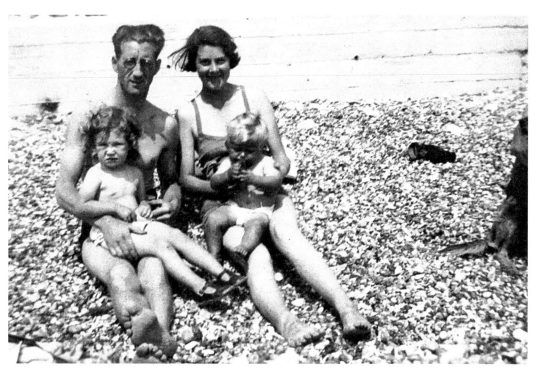

My parents Fred and Tess are seen here on the beach in the Warren holding my sister, Marion, and myself. The photograph was taken in the summer of 1937.

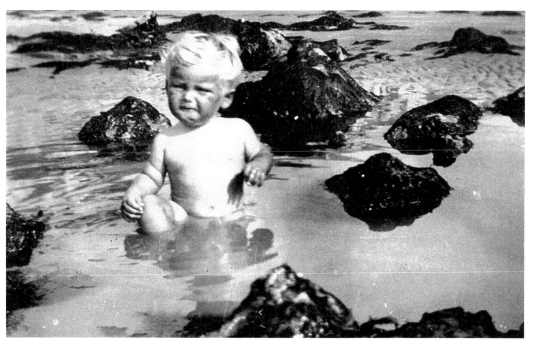

Another image of me sitting in a rock pool in the summer of 1937; by the expression on my face I should think the water was quite cold!

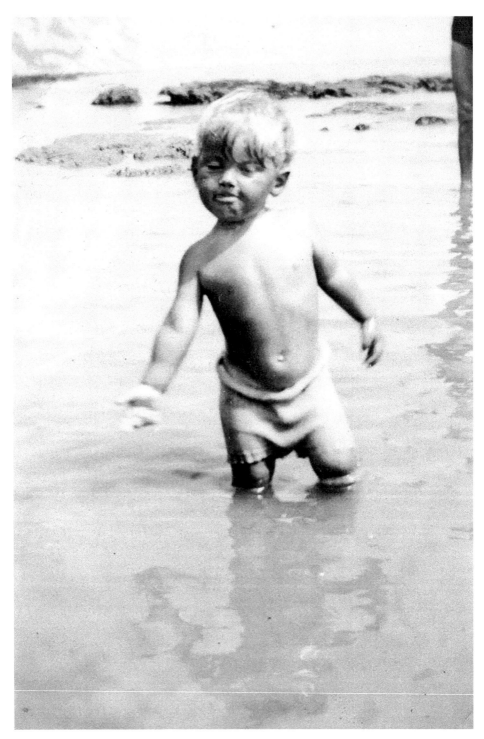

This is me standing in a rock pool in the summer of 1938. Did you have a knitted costume like mine? Not very good when they got wet as they sagged down round your knees due to the weight of water!

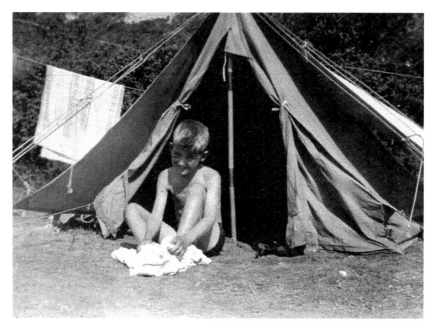

After the Second World War we resumed camping after the mines were cleared from the Warren in 1946. This is me sitting in the entrance to the tent I shared with my sister. We moved from this site in 1948 due to a railway siding being built through the site to park goods trucks carrying ballast, etc., for the first apron being built to stabilise the sea wall, which had been forced out a metre since the start of the war. This was partly due to no maintenance work being carried out during the war years.

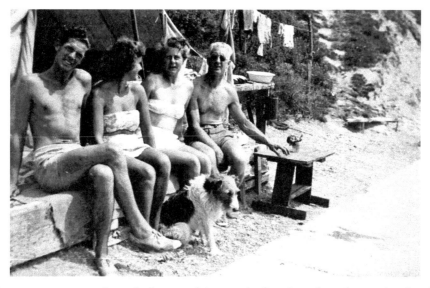

This was our new campsite at the bottom of the steps leading down from the Royal Oak public house. Seen here in 1953 are, from left to right, Jack Chandler, his wife Joan, my mother Tess and father Fred. Jack Chandler was brought up in the Warren with the rest of his family until war broke out in 1939 when they had to move. My family, along with other families, camped here, leaving their tents and equipment all the summer until 1960.

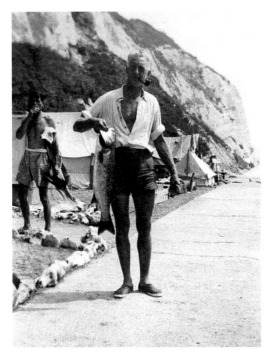

We had a 9-foot rowing boat that we left at the Warren and went out fishing in. Sometimes my mother would row the boat while my father was spinning for bass by the deep rocks at Lydden Spout. My father is seen here posing for the camera holding a nice bass.

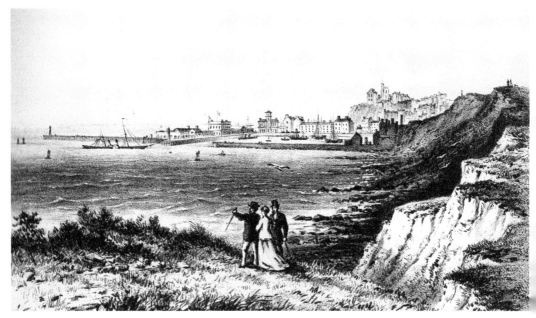

A reference from Nelson's guide: 'A harbour existed here prior to the reign of Henry VIII, which, in that reign, was considerably improved. We conceive it; however, to have been little more than a quay, or landing-place, for boats and vessels of small burden; and even this, in 1709, was in so deplorable a condition that it became necessary to protect it by the erection of three jetties of timber and stone. In the storms of December 1724, these were swept away, and the town remained without haven or protection until 1808, when under the direction of Telford, two solid stone piers were erected.' These stone walls are the ones we see today in the inner and outer harbour.

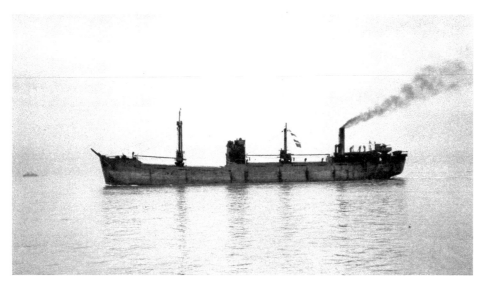

SS *Empire Lough* was a collier built by William Gray & Co. Ltd, of West Hartlepool, in 1940 for Stanhope Steam Ship Company. She was taken over by the Ministry of War Transport and on 24 June 1944, while on passage between Folkestone and Dover, she was hit by a German shell fired from a long-range gun on the French coast. She was carrying a cargo of cased petrol and ammunition, which immediately caught fire. The Dover tug *Lady Brassey* went to her assistance in fighting the fire, but explosions and flying bullets compelled her to leave. Later, she took the ship in tow and beached her at Lydden Spout. She was later refloated and beached on the Sunny Sands to be broken up. I can remember diving from the remains of her during the summer of 1945.

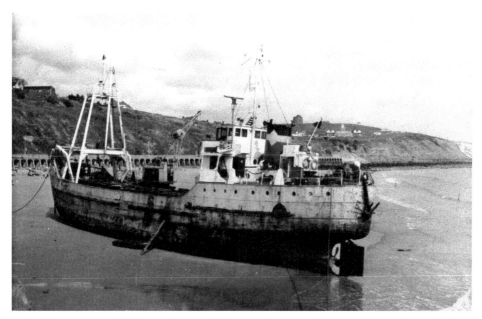

This coaster called *Kay Belle*, formerly *Scaly Bridge*, was converted by Folkestone Salvage Company to carry out salvage work. She was put on the Sunny Sands in September 1974 to carry out minor repairs. At the time the salvage company had a contract to blow up some of the large wrecks in the Channel so the super tankers would not hit them.

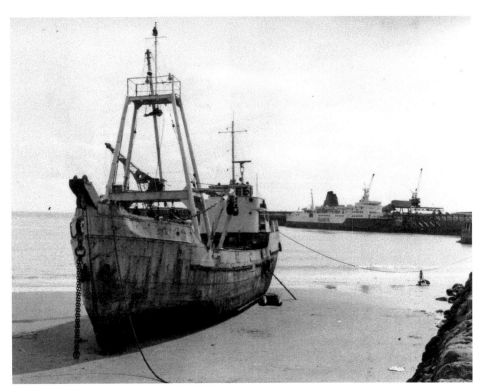

Another view of the *Kay Belle* with the pier in the far distance. The ship moored in the car berth is the multi-purpose French Ferry MV *Chartres*, owned by SNCF. She was built in 1974 and could carry 1,400 passengers, 250 cars and had 350 linear metres for HGVs (heavy goods vehicles).

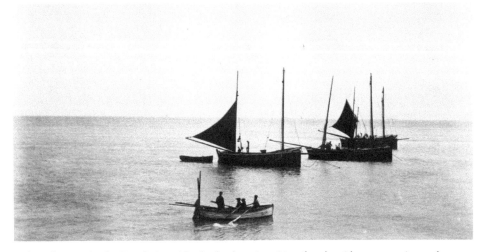

Fishing luggers in the Roads (outside the harbour) waiting for the tide to come in so they can enter the outer harbour, *c.* 1900. The rowing boat in the foreground would mainly have been used for drift net fishing, catching sprats and herrings. The lugger nearest the camera is FE67 *Bonnie Margaret.* Built in Porthleven in 1895, she had two owners – A. E. May and E. Nicholls. Behind her is FE75 *Jane*, which was also built in Porthleven in 1898. She had one owner William May. The third lugger cannot be identified.

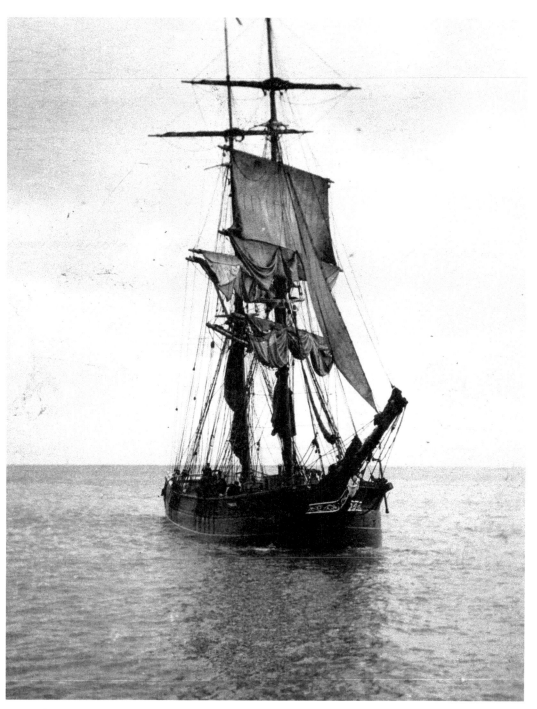

The sailing ship *Primrose* approaches the entrance to the outer harbour. All these sailing ships had to take a pilot known as 'mud pilots'. Most of them were Folkestone fishermen. Two that come to mind are Henry 'Gare' Sharp and William 'Pin' Carter. The *Primrose* was built by Dennison at Sunderland in 1864 and registered at Folkestone in 1883. Thomas Henry Franks (sailmaker) of Folkestone was the owner. The vessel was broken up in 1907.

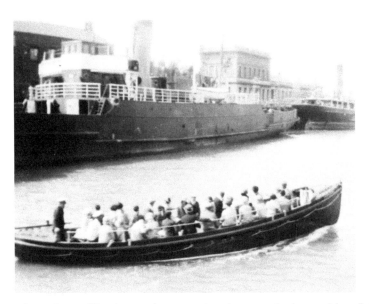

The pleasure boat *Ocean King* is seen here entering the outer harbour with a full load of passengers. Harry James Sharp purchased her from Eastbourne in 1922, formerly the Eastbourne pulling (propelled by oars) lifeboat *Olive*, which was sold when she went out of service after being replaced with a motor lifeboat. The *Ocean King* was licensed to carry thirty-six passengers and was last licensed in 1947.

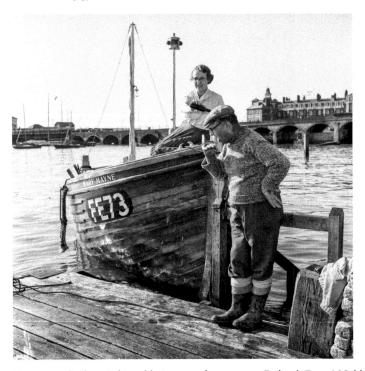

FE73 *Mary Mayne* was built at Whitstable in 1959 for partners Roland 'Fergy' Noble and Don Mayne, landlord of the Jubilee Inn. Seen in the picture at the market steps are Fergy Noble and Mary Mayne, who is officially naming the vessel with a bottle of pale ale.

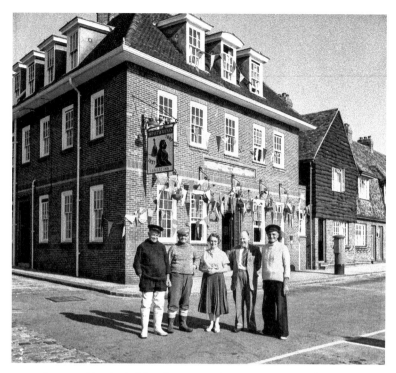

Seen here standing outside the Jubilee Inn (now the Mariners) are, from left to right, Jack Saunders, Roland 'Fergy' Noble, Mary Mayne (wife of the Jubilee's landlord), landlord Don Mayne, and Johnny 'Soup' Featherbe.

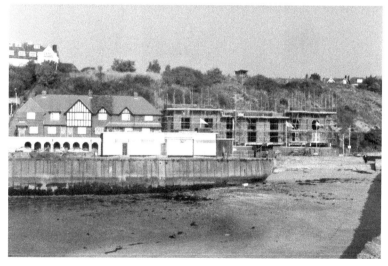

This photograph is showing the Harbour Point flats being constructed at the east end of the Stade in 1988. The site had previously been occupied by the Sunny Sands Restaurant, which opened in 1960 on the site of the former South Eastern and Chatham Railways Company's marine workshops. They moved to Dover in 1922, at which time it was Southern Railway who sold the workshops to Folkestone Council in 1927 for £3,200. The council used the workshop for bathing cabins, etc., before they were demolished to build Sunny Sands Restaurant.

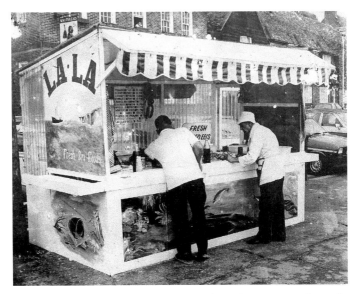

The most eastern Whelk Barrow on the Stade, La-La belonged to La-La Taylor and was opposite the Jubilee public house (now the Mariners). Seen here with his back to the camera is La-La, followed by his employee Bill Longhurst. This photograph was taken in the early 1980s. Today the whelk stalls are like mobile shops and the staff are actually inside them serving customers on the outside.

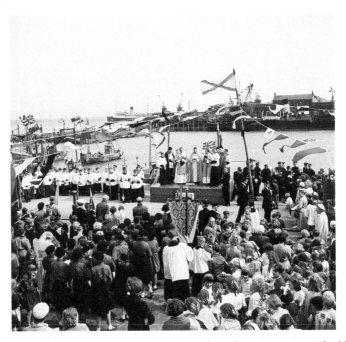

Blessing of the Fisheries, c. 1960, an event that has taken place since 1893. The blessing takes the form of a long procession from the church to the Stade via North Street and Radnor Street, which is led by the servers, choir and clergy, preceded by the Processional Cross. Unfortunately the large increase in road traffic prevents it taking the 1930s route across Radnor Bridge and through Harbour Way (formerly Dover Street).

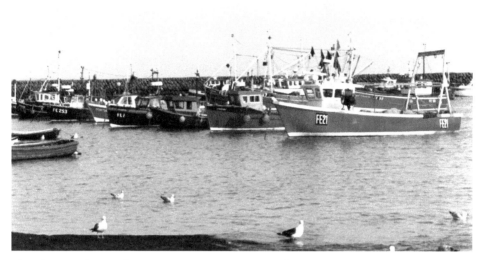

This photograph was taken in August 1992. None of the fishing boats seen here are fishing in the present day. Most of them have been sold due to the decline in the fishing industry.

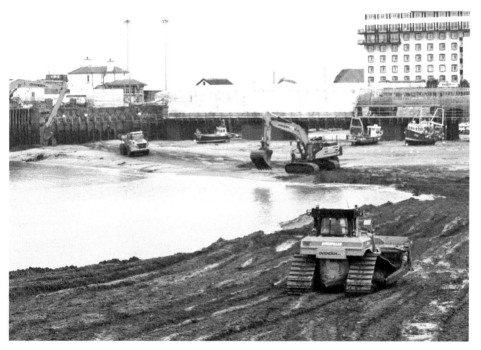

This photograph, taken on 4 April 2017, shows the outer harbour being dredged by Folkestone Harbour Company. It was not only to clear the sand banks in the harbour, but to use the sand on the west beach to help raise the beach level by 1 metre before the site is developed. This is to protect the buildings from global warming over the next 200 years.

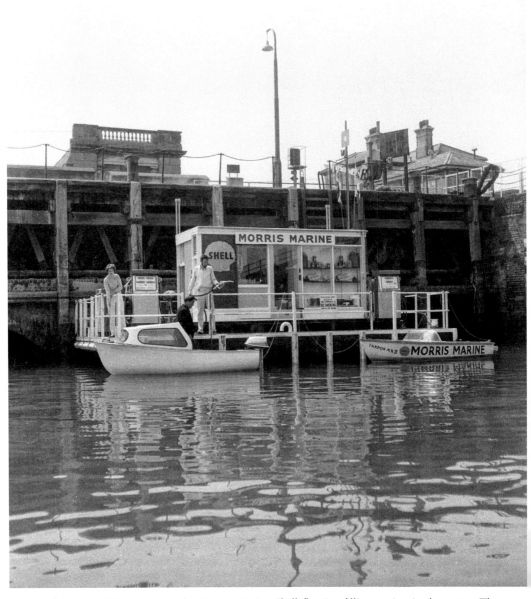

A new venture for Folkestone was the Morris Marine Shell floating filling station in the 1960s. The photograph was taken in May 1962 when it was moored on the South Quay. It didn't survive for many years, partly because of the harbour being tidal.

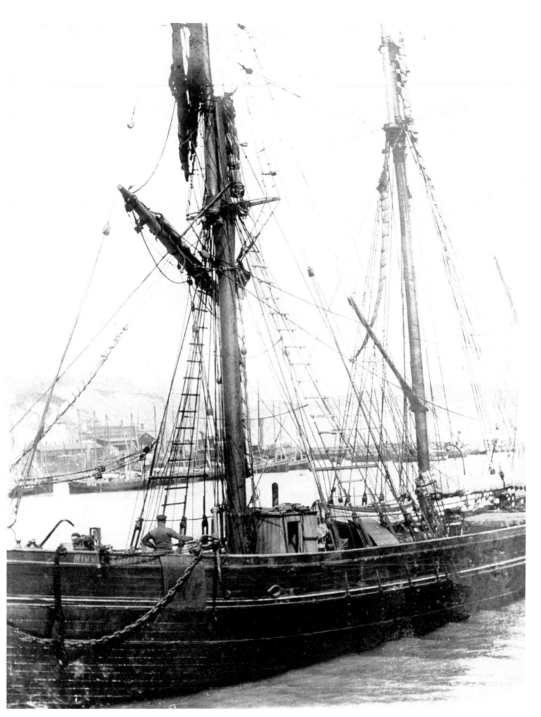

The Brigantine *Minnie Summers* is seen here about to enter the inner harbour, where there could be as many as ten ships unloading their cargoes of timber, ice or coal. She was built at Porthreath, Cornwall, in 1876, registered at Folkestone in 1903, and owned by George Nicholls. The vessel was lost in 1920.

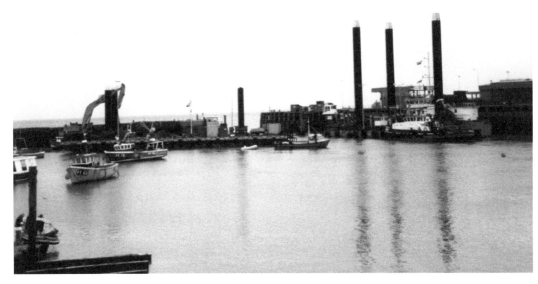

Seen here in the outer harbour are Dutch rigs, which were working on the new sewerage treatment works off the Sunny Sands. They were forced to shelter in the harbour due to gale-force winds in July 1998.

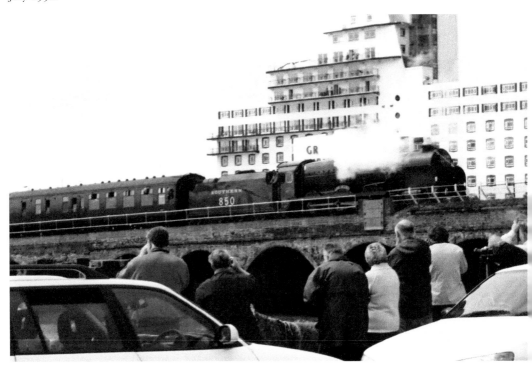

The steam train *Lord Nelson* on the harbour branch line being operated as the Golden Arrow, 16 August 2007. She is a SR class 4-6-0 steam locomotive designed for the Southern Railway by Richard Maunsell in 1926. They were intended for the continental boat train service between London Victoria and Dover. They were withdrawn between 1961 and 1962.

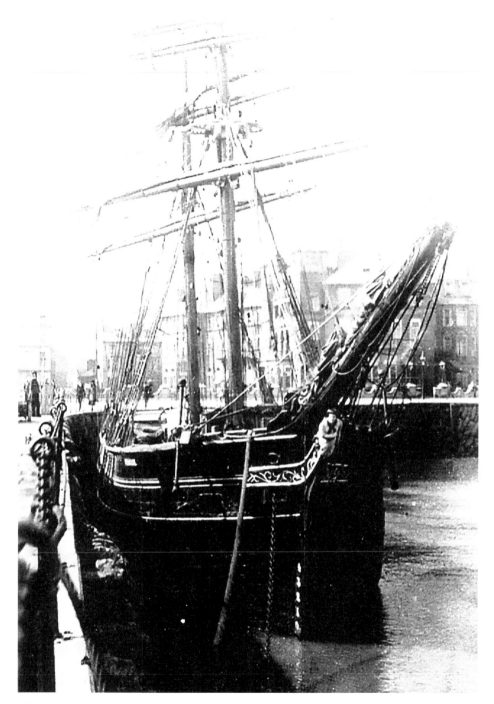

The Brigantine *Minnie Summers* moored in the inner harbour, facing bow out. She is in the berth that was usually used for unloading cargoes of coal or ice. It's interesting she has a figurehead on her bow. They were carved wooden decoration found on ships generally of a design related to the name or role of the ship. They were predominant between the sixteenth and twentieth centuries.

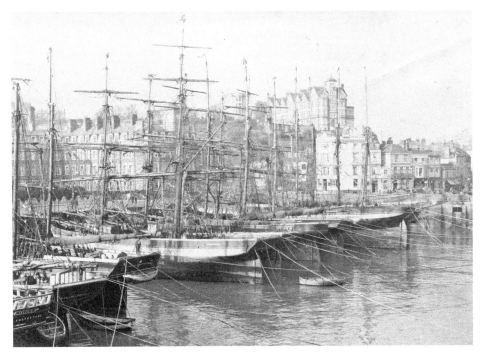

Seen here moored bow to the quay in the inner harbour, *c.* 1900, are seven sailing ships their names are, from the left to right, *Celorio*, *Cumberland Lassie*, *Cypress*, *Catherine*, and *Scotia*. They were all registered at Folkestone.

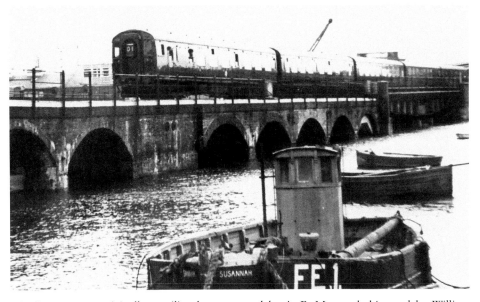

FE1 *Susanna* was originally a sailing lugger owned by A. E. May and skippered by William 'Cod' Baker. She had a 13 horsepower Kelvin petrol/paraffin engine, which was fitted in 1915. The vessel was purchased by William Graying in 1954, seen here moored in the inner harbour on what was called 'The Pent' because the pent steam runs out into the harbour. The photo was taken in 1961 just before she was broken up.

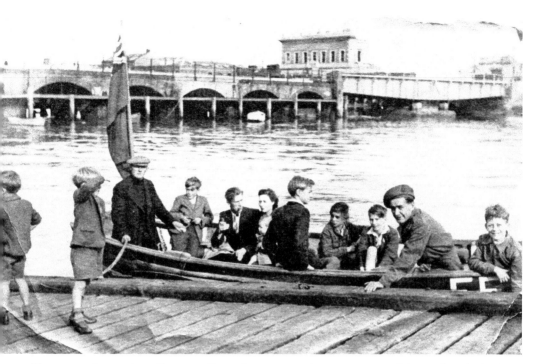

The motor pleasure boat *Tessa* was licensed to carry twelve passengers, and is seen here in the inner harbour alongside the slipway with her passengers, *c.* 1945. The skipper is Horace Brickell, to his right is his son John and the man in the army uniform is Jim Barber, who was Horace's brother-in law, and to his right is David Brickell, Horace's other son. My late father brought this boat in 1932 from Brighton, calling it *Tessa* after my mother.

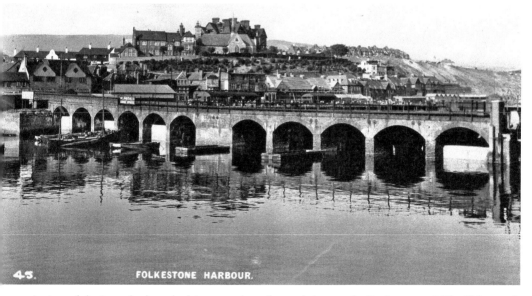

FOLKESTONE HARBOUR.

A view of the inner harbour looking over the railway viaduct to the Stade, *c.* 1936. The Fisherman's Bethel and fish shed 1 and 2 can be seen from the left hand side. The row of houses including the Ship Inn, between the current Captain's Table and Mariners, are under construction.

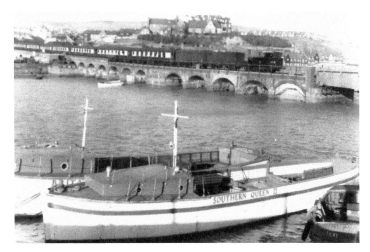

In the foreground are the *Southern Queen II* and *Britannia*, which were both used for carrying passengers. *Southern Queen II* was built by the Short Brothers of Rochester in 1926 for Folkestone fisherman Edward Saunders. She was licensed to carry seventy-seven passengers and operated from Folkestone from 1926 to 1939. Then in June 1940 she was one of the little ships that went to Dunkirk. She returned to Folkestone in 1946, at which time she was owned by Albert Edward Bellingham until 1961. The following year she was sold and went to St Mary's, Isles of Scilly. The *Britannia* was built for the Admiralty towards the end of the Second World War. At the end of the war she was purchased by Henry James Sharp and converted to carrying passengers. She was licensed to carry sixty-two passengers, and operated from 1948 to 1963, when she was also sold and went to St Mary's, Isles of Scilly.

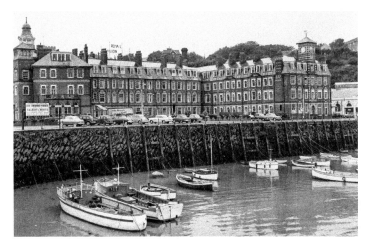

The Pavilion Hotel was purchased by Mr Burstin from Southend-on-Sea, who converted it into flats for the elderly, the first of which was occupied in September 1960. He demolished the hotel in 1981–82 to make way for the Burstin Motel, which was managed by his son Ivor. The Burstin Motel was sold in 1988 to Land Leisure Plc, becoming the Hotel Burstin. The premises have changed hands a number of times since and are currently owned by Britannia Hotels Group, who changed the name to Grand Burstin.

The pleasure boats *Britannia* and *Southern Queen II* can be seen in the foreground. The Southern Queen was towed back to the UK from the Scilly Isles in 1998, restored at Penzance and sailed to Dunkirk for the Little Ships Anniversary in June 2000.

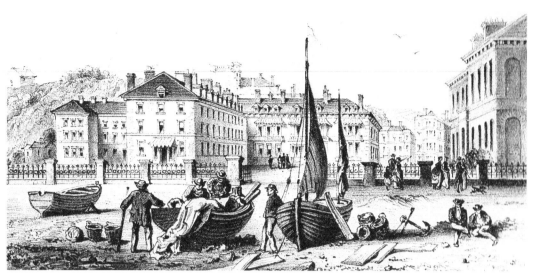

Extract from Nelsons' guide: 'The pavilion Hotel deserves to be ranked among the public buildings of Folkestone; it enjoys a world-wide reputation for the excellence of its arrangements and the moderation of its tariff. Erected in 1843, from the designs of Mr. W. Cubitt, it then consisted of two wings, running east and west; but the rapid increase of the patronage awarded it rendered necessary the addition of a third wing in 1844, and of a fourth in 1850. The surrounding grounds are laid out in a very attractive manner, and command from every point the most enjoyable views of the sea and harbour.

In its present condition the Pavilion forms an irregular four-sided structure – of which two sides are each 150 feet long, and two about 90 feet. It consists of four stories, and makes up nearly 200 beds.'

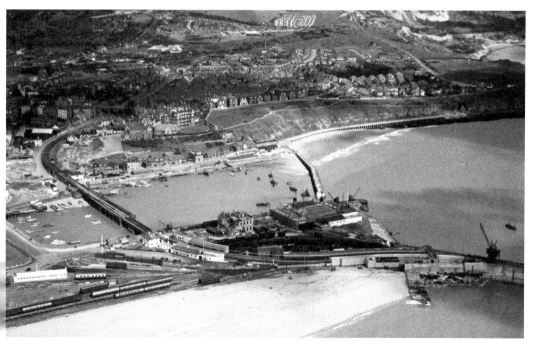

An aerial view, c. 1951, showing the railway sidings on the west side of the harbour station. The sidings were removed in 1961 when the line was electrified.

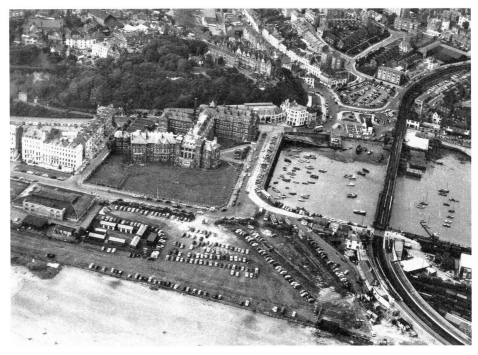

An aerial view taken in 1963 showing, from left to right, the Marine Gardens Pavilion, which became the La Parisienne nightclub before changing it's name to Onex nightclub, which was demolished in 2016, followed by Peden's stables and a car park that were both on the site of railway sidings. The Pavilion Hotel can be seen next to the inner harbour and is now the site of the Grand Burstin Hotel.

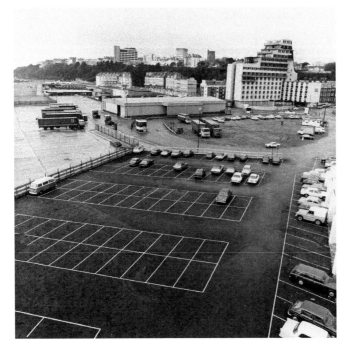

It's interesting to compare this image (taken in 1977) with the last one showing the area completely transformed after the building of the car ferry berth. It shows the car parking areas, the freight customs clearing sheds, the half-built Burstin Motel and the remains of the Pavilion Hotel.

With larger steamers with deeper drafts now on station on 16 August 1861, a 600-foot-long 'New Pier' was officially opened adjacent to the old groyne on the south-east side of the shingle spit beyond the South Quay berths. The railway lines (as seen here) were extended out towards the pier head. This is an extremely rare view taken in around 1870.

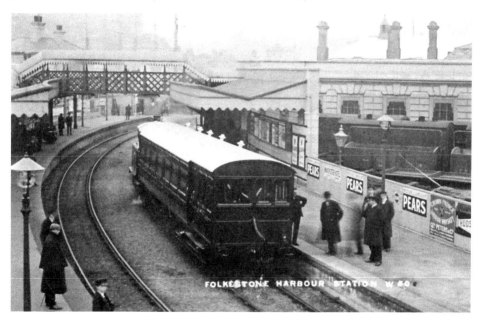

Seen here parked on the down platform at the Harbour Station, *c.* 1903, is a South Eastern & Chatham Railway Company railcar, also known as 'push-pull'. It's a vehicle that does not require a locomotive as it contains its own steam engine and could be driven from both ends. On the right-hand side of the photograph is the Custom House, which was built in 1859.

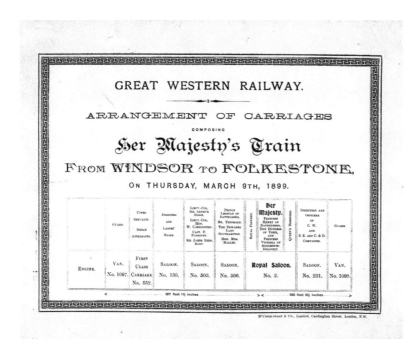

GREAT WESTERN RAILWAY.

ARRANGEMENT OF CARRIAGES

COMPOSING

Her Majesty's Train

FROM WINDSOR TO FOLKESTONE,

ON THURSDAY, MARCH 9TH, 1899.

	Guard.	Upper Servants, Indian Attendants.	Dressers and Ladies' Maids.	Lieut.-Col. Sir Arthur Bigge. Lieut.-Col. Hon. W. Carrington. Capt. F. Ponsonby. Sir James Reid, Bart.	Prince Leopold of Battenberg. Mr. Thognald. The Dowager Lady Southampton. Hon. Mrs. Mallet.	Royal Footmen	Her Majesty.	Princess Henry of Battenberg. The Duchess of York, and Princess Victoria of Schleswig-Holstein.	Queen's Dresser	Directors and Officers of G.W. and S.E. and C. & D. Companies.	Guard.
Engine.	Van. No. 1097.	First Class Carriage No. 552.	Saloon. No. 130.	Saloon. No. 503.	Saloon. No. 506.		Royal Saloon. No. 2.			Saloon. No. 231.	Van. No. 1098.

< ———— 197 feet 11½ inches ———— > < ———— 130 feet 10½ inches ———— >

M°Corquodale & Co., Limited, Cardington Street, London, N.W.

This is an extremely rare document detailing the arrangement of carriages for Queen Victoria's last visit to France. The Great Western Railway train came from Windsor to Folkestone on Thursday 9 March 1899. It gives the details of who is in each carriage and the length of the train, etc.

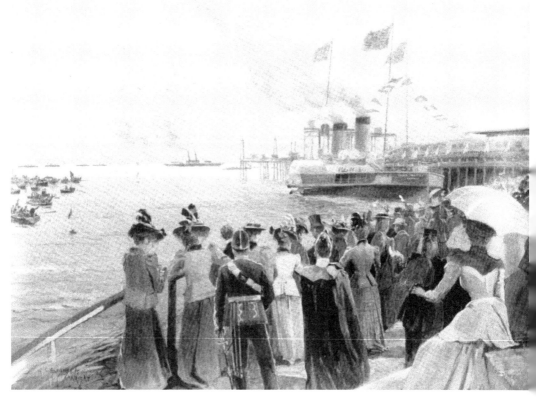

Queen Victoria made her very last cross-Channel crossing between Folkestone and Boulogne on 9 March 1899. Steamer *Calais-Douvres (11)* was employed as the royal yacht.

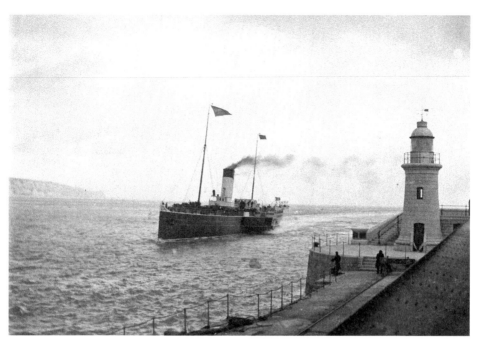

The vessel approaching the harbour is the French steamer *Le Nord*, which usually operated the Calais–Dover service with her sister *Le Pas de Calais* (although they generally didn't operate together – one was on standby while the other was in operation). On Good Friday (22 April) 1905, she was chartered to carry 800 Paris butchers for a day trip to Folkestone, where they remained for five hours.

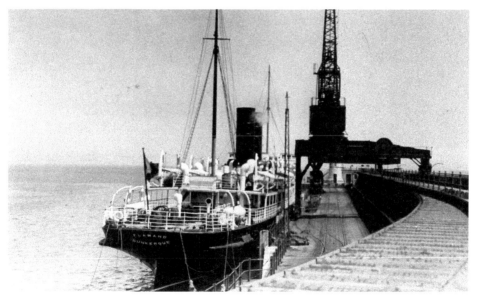

The *Flamand*, formerly the *Londonderry* of the Heysham–Belfast service, was built in 1904. Her name was changed for her new owners Societe Anonyme de Navigation Alsace-Lorrain-Angleterre and she was on the Folkestone–Dunkirk service from 1932 to 1936, after which she was scrapped.

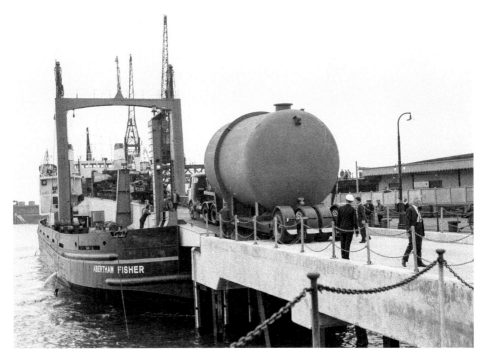

In 1965 the Central Electricity generating board (CEGB) built this cargo ramp on the pier for the heavy plant being used in the construction of Dungeness B nuclear power station. Seen here is the *Abertham Fisher* unloading a large tank for Dungeness power station. In the spring of 1970 British Railway announced it was spending £1 million investment to build a Ro-Ro car ferry facility at Folkestone Harbour, and the CEGB cargo ramp was relocated to the South Quay.

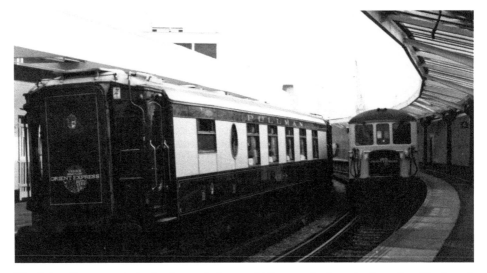

The Orient Express train in the down platform at Folkestone harbour in the 1980s. The launch of the luxury Venice-Simplon Orient Express on 26 May 1982 provided much positive publicity for the ferry service, passengers crossing the Channel via Folkestone and Boulogne on Fridays and Sundays. For the duration of the crossing, the forward lounges on B deck in the *Hengist* and *Horsa* were exclusively reserved for Orient Express passengers.

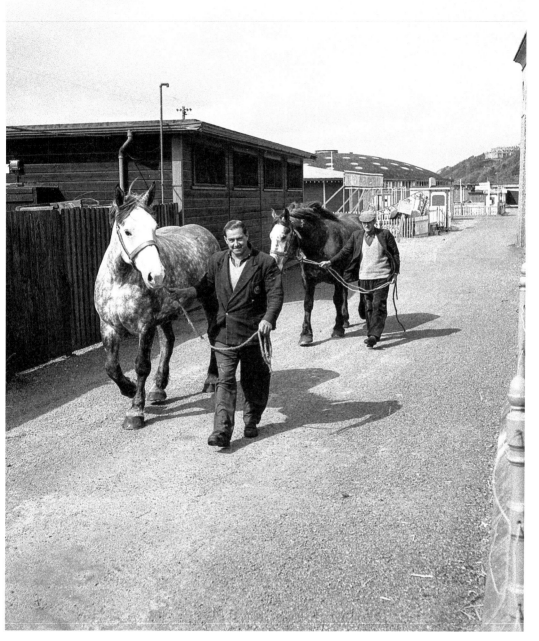

Tom 'Darky' Lee, followed by Bob Ottley, are taking these racehorses round to the harbour to board the cargo steam for Boulogne in May 1961. The stables are on the left-hand side of the photo, while the Marine Gardens Pavilion is on the right, and in the far distance are the amusements including the Rotunda!

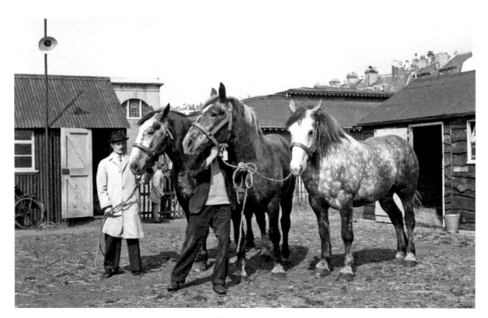

Peden & Son, horse shipping agents (Pavilion stables), were at the bottom of Tram Road but were demolished to make way for Boulogne Court, which was built in 1960. New stables were erected on part of the railway sidings that ran from the harbour westwards. I helped dismantle these stables in September 1965 when the racehorses were being flown to France from Lydd airport by Silver City Airways.

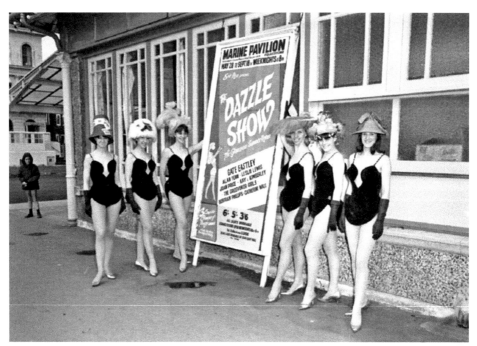

The summer show Dazzle at the Marine Gardens Pavilion in 1965. Eric and Ida Ross are the summer show proprietors; they produced the famous 'Dazzle Cabaret' floor show. This is their fifth season at Folkestone, and they also produced Dazzle here from 1950 to 1953.

Among the stars in the 1965 Dazzle Show is: Kay and Kimberly, a Canadian dance act, and Leslie Lewis, a comedy impressionist who is known as the 'Perfect Host'. Joan Price has been with Dazzle before, but not at Folkestone, and she sings 'With a song in my heart'. The opening chorus was sung by Gate Eastley, Allan Finn, Leslie Lewis, Joan Price, Kay and Kimberly, Pauline Cottis, Lorna Nathan, Linda Guest, Susan Oliver, Wendy Fielding and Ann Mitton.

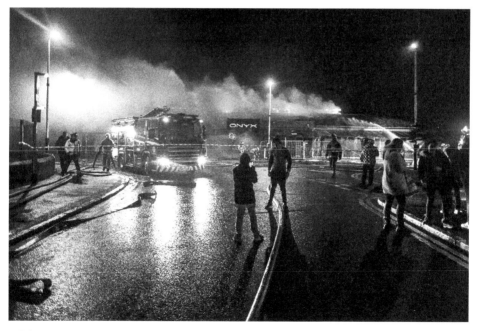

While the Onyx nightclub was waiting to be demolished, the building went up in flames in January 2016. The building was built in 1926 as Marine Gardens Pavilion and converted into a nightclub called La Parisienne before being renamed Onyx.

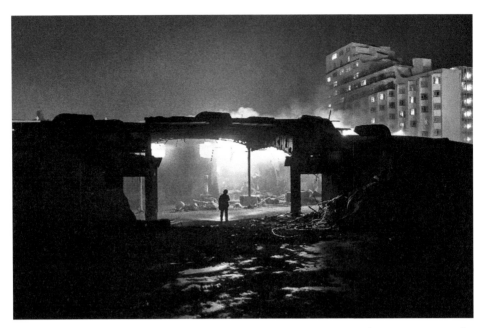

The Onyx nightclub gutted by the fire in January 2016. It was a great disappointment to the clubbers, who didn't approve of the building being pulled down. Historic England did assess the application to list the building, but the decision by culture secretary John Whittingdale was that the building lacked architectural interest for it be listed.

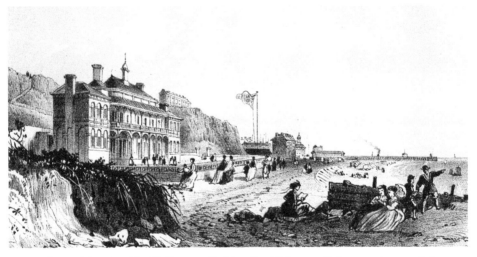

Extract from Nelson's guide: 'Folkestone Bathing Establishment; Folkestone is one of the most progressive towns on the southern coast. The "Lees" have, of late years, been covered with handsome buildings. Foremost among the latest improvements is the new Bathing Establishment and Subscription Rooms – an Italian structure, with a frontage of 117 feet, and a depth of 48 feet. It contains a number of medicated and invalid baths, and a large swimming-bath, on the basement; a large series of hot and cold, fresh water and salt water, baths for the ladies and gentlemen, on the first floor; and upper tier are situated ball – rooms, corridors, reading, billiard, and refreshment rooms, all fitted up in the most luxurious style. The annual subscription is 25s (£1.50), or for the season of six months, 18s (£0.80). The Manager is Mr. Julius Thompson.'

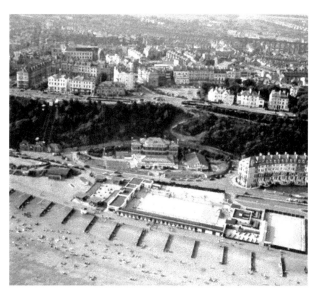

An aerial view, *c.* 1955, showing, from the left-hand side, the Rowing Club, open air swimming pool, and open air roller skating rink, behind which the Leas Lift, Marina, formerly the Bathing Establishment, and part of Marine Crescent can be seen.

The first Guinness Clock was produced by Guinness for the 1951 Festival of Britain, held in Battersea Park. It was designed by the firm of Lewitt Him and constructed by clockmakers Baume & Co. Ltd. It was such a success that Guinness received requests from department stores and theme parks to borrow the clock. Guinness created eight clocks, which toured the coastal tourist resorts.

Every quarter of an hour brought a frenzied burst of activity from an assortment of the characters created by the artist John Gilroy to advertise GUINNESS – the animals and their zookeeper, accompanied by fairground music. The zookeeper began the sequence by emerging from a tower and ringing a bell. After the zookeeper an assortment of other animals would emerge, one after the other, each performing their own set piece and then withdrawing back into the clock in reverse order. After around five minutes, the sequence was finally brought to a conclusion by the zookeeper once again ringing his bell.

The one seen here was placed on the Marine Gardens in front of the swimming pool. It's interesting to note that on the left you can see part of Marine Crescent.

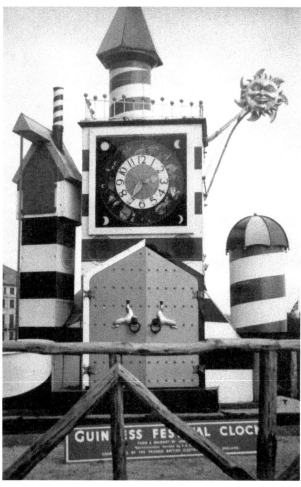

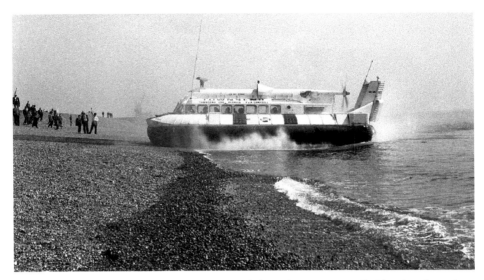

This Westland SRN6 hovercraft got the go ahead from the town council's Planning Committee to take pleasure trips. There were comments from the hoteliers along Marine Parade and Terrace, mostly about the noise, but in general they thought it would be good for the town. It started running in May 1966, but it only lasted for six weeks because it kept rolling down the beach, rupturing its ballast tanks.

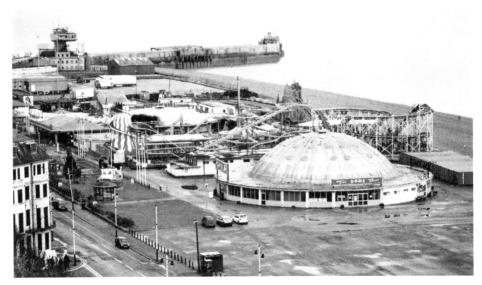

In June 1981 Mr Godden acquired the freehold of the Rotunda and 14 acres of the seafront from Marine Pavilion to the Lower Sandgate Road. The swimming pool was filled in and the entrance building was converted into a café, with the boating pool following in 1983. The area was covered with tarmac to enable amusement rides to be erected. The Rotunda Dome gained a sister building in 1984 when the dome was brought over from Holland and filled with amusement machines, café and children's play area. May 2002 was the final year of the full park opening. Roger De Haan struck a deal with Jimmy Godden to purchase the seafront in November 2006, by which time most of the amusements had been cleared away.

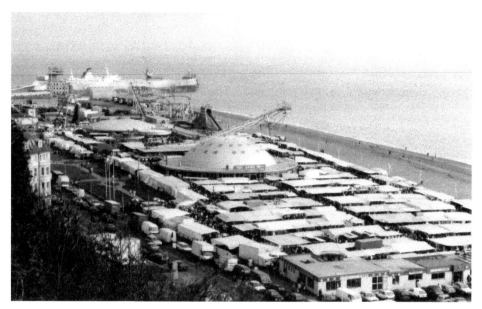

The Sunday market in its heyday. The market was established by Jimmy Godden in 1984. The image shows what a large number of stalls there were. Coach loads of people came from further north than London, and it was good for other local traders such as cafés, pubs, whelk stalls and fish shops. When the site was sold to Roger de Haan in 2006 Jimmy Godden moved the market into the town.

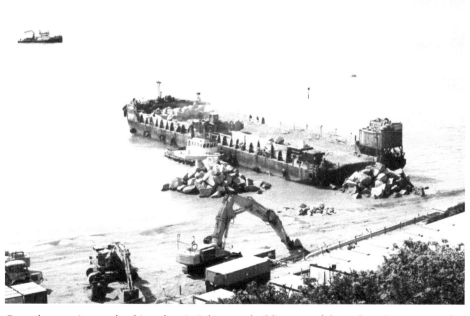

Coastal protection work taking place in July 2004, building one of the rock groins as seen today, which were designed to build up the beach, to protect the sea and to stop the easterly drift of shingle from the prevailing south-west winds and tides.

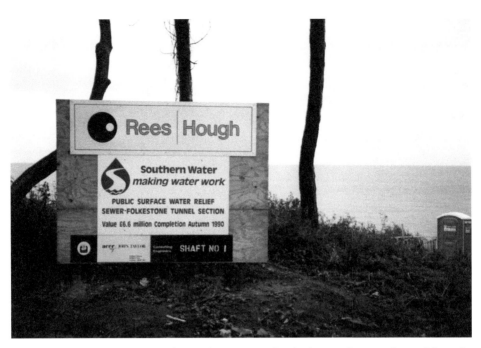

Rees Hough were the contractors for Southern Water. They built an underground tunnel from the Channel Tunnel terminal at Cheriton to drain the surface water from the site. This photograph was taken along the Lower Sandgate Road, opposite the Metropole Hotel.

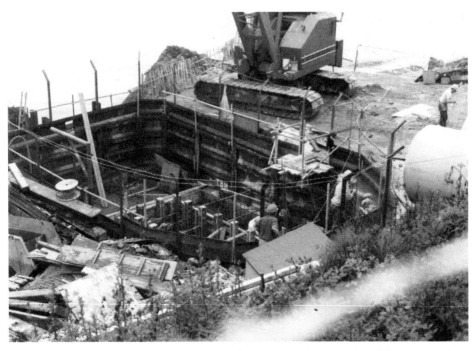

A water chamber is being constructed between the Lower Sandgate Road and the promenade to hold the surface water from the Channel Tunnel Terminal, Cheriton, before it is discharged into the sea, October 1989.

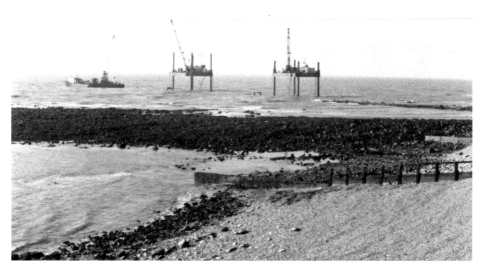

These rigs are just the west side of Mill Point (the rocks in the foreground), laying the pipe that will run around a quarter of a mile out to sea to discharge the surface water from the Channel Tunnel Terminal, October 1989.

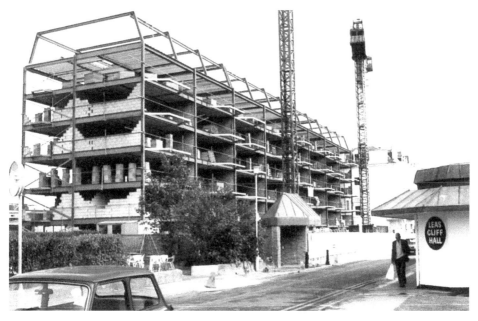

Carlton Leas, a complex of forty-eight flats, was built on a car park (next to the South Cliff Hotel), by Kingston Homes in 1988. The flats were opened on 9 June 1989 by TV personality David Jacobs at the Carlton Hotel. The car park was replaced with an underground car park for the Leas Cliff Hall and town. Note the red-brick walls with a canopy over the top that is the entrance to the underground car park. Building work started on 9 October 1987, costing £1.46 million and providing 185 parking spaces.

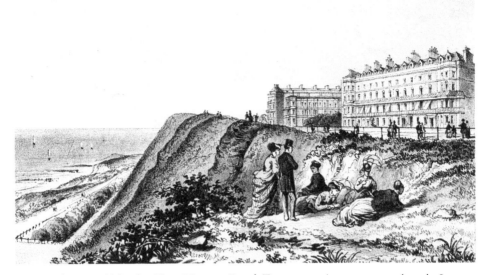

From Nelson's guidebook: 'New Houses, *Royal Terrace* erection commenced 24th January 1863. Numbers 23 & 24 became the *Skelmersdale Private Hotel c.* 1894. By 1927 the hotel had expanded by acquiring No. 22. In 1934 its name changed to *Ambassador Hotel* (Hall's Hotels, Folkestone, Ltd). In April 1974 there was a fire at 25 the Southcliff Hotel, owned by Joyam Hotels Limited, Jim Hyham being company secretary and manager after the fire costing £40,000 to put the damage right, Nos 22, 23, 24, 25 & 26 became the *Southcliff Hotel* owned by Jim Hyham.'

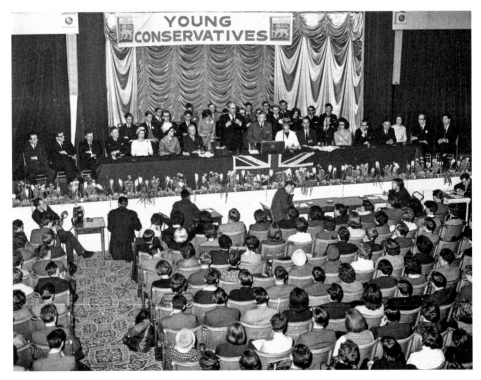

Ted Heath at the Young Conservatives meeting in the Leas Cliff Hall in 1964.

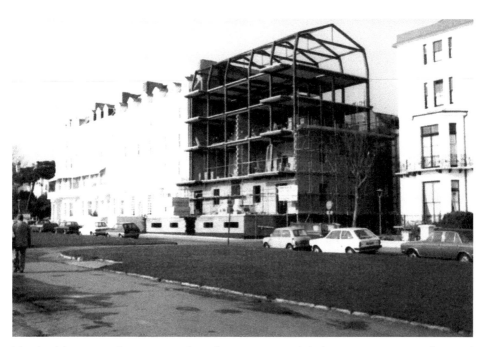

The Castlehaven Hotel at Nos 20 and 21 The Leas (corner of Shakespeare Terrace) was destroyed by a long-distance shell on 25 September 1944. This complex of flats called George Cooper House was erected on the site by Jimmy Hyham.

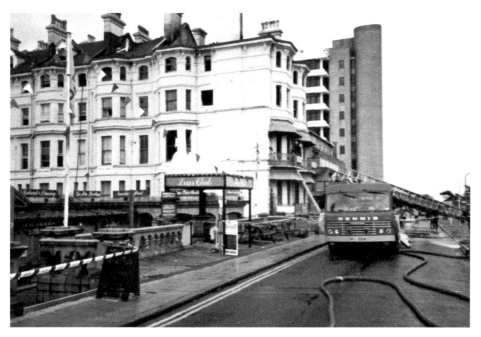

Kantilal Taylor, forty-two and of no fixed address, died from head injuries before his body was badly burned in the blaze at this disused Hotel de France (formerly the Langhorne Hotel). The fire started at 5 a.m. on 11 September 1993. The four-storey hotel was in such a dangerous condition that it was later demolished. The site is now a car park.

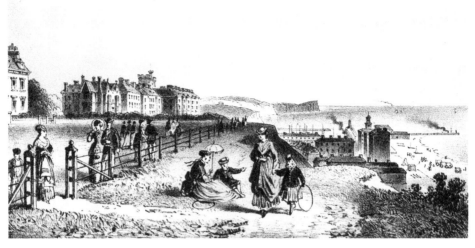

Extract from Nelson's guide: 'Priory Terrace East Lees, a very charming promenade; West Cliff and Albion Terraces, in the Sandgate Road; West and Cannobie Terraces, leading from the latter to the Lees Eldon Villas, Pleydell, and Langhorne Gardens, on the West Cliff; Bouverie Square, Radnor Terrace, and North Pleydell Gardens, in the Upper Sandgate Road; Marine Parade; and Marine Terrace. Excellent shops will be found in Rendezvous Street and Harbour Street.'

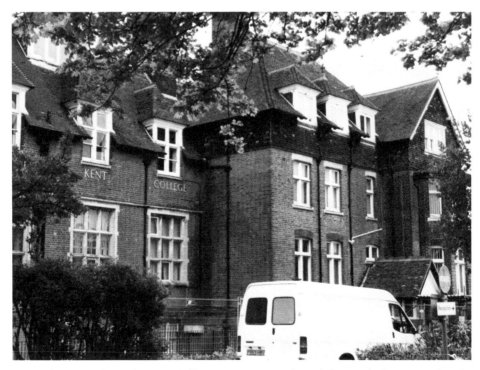

Front elevation of South Kent College, Nos 34–38 Shorncliffe Road, facing south. The photograph was taken on 6 May 1999, and the building was demolished during May and June 1999. The building was formerly the Grange School for young gentlemen, which was opened by Revd Arthur Hussey in 1883–85. In 1937 the building became the Technical Institute and Junior Commercial School, before finally becoming South Kent College.

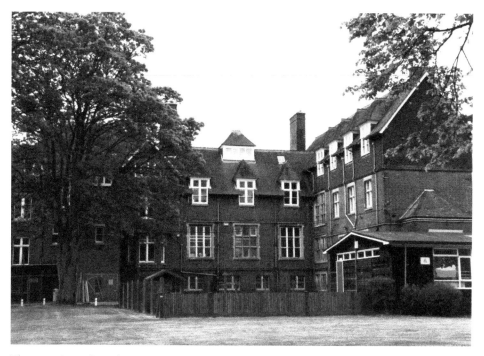

The rear view of South Kent College, facing north. The photo was also taken on 6 May 1999, just before the building was demolished.

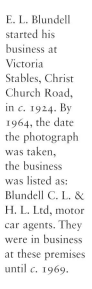

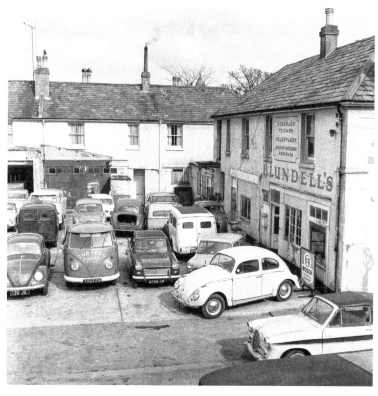

E. L. Blundell started his business at Victoria Stables, Christ Church Road, in *c*. 1924. By 1964, the date the photograph was taken, the business was listed as: Blundell C. L. & H. L. Ltd, motor car agents. They were in business at these premises until *c*. 1969.

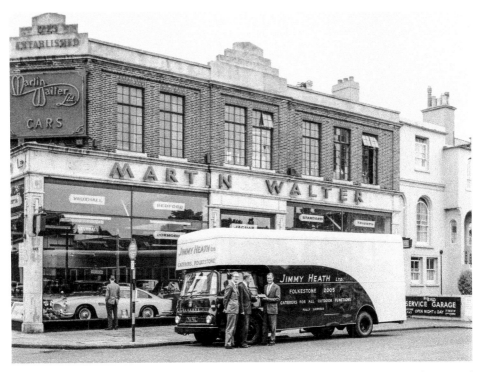

Jimmy Heath's pantechnicon is seen here outside Martin Walter's showroom in Sandgate Road on the corner of Shakespeare Terrace. The body of the vehicle was made by Martin Walter's, and vehicle is being handed over to Jimmy Heath by the manager of Martin Walter's in June 1961.

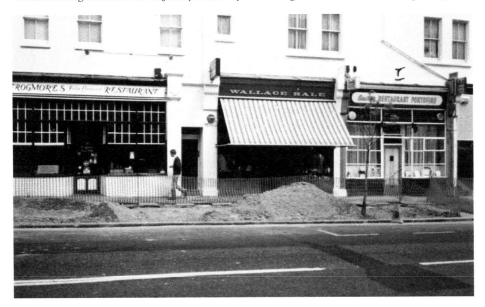

The Frogmores Restaurant, No. 28 Sandgate Road, was owned by Channel swimmer Sam Rockett from 1964 to 1982. It is currently occupied by Pizza Hut. Wallace Hale Ltd, tailor's and men's outfitters at No. 126 Sandgate Road, was in business from c. 1960 to February 2001. It was one of the last good quality independent men's shops in Folkestone.

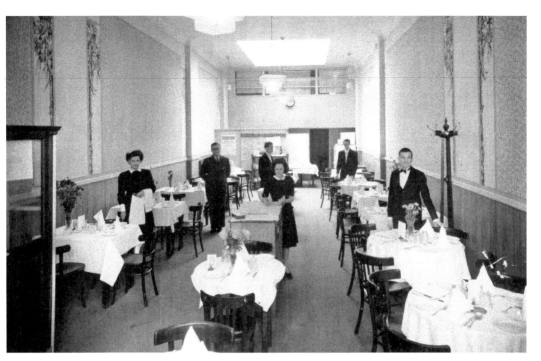

The interior of Charles's Grill, No. 123a Sandgate Road. The proprietor Lonnie Panero was bombed out of Nos 24 and 26 Beach Street on 18 November 1940, after which he took this shop. He is seen here on the right-hand side wearing the bow tie. Note two posters in the background, which are for the Leas Cliff Hall, and one of them is advertising a concert with Alfredo Campoli, the famous Italian violinist. The restaurant was the Portofino, which has now closed and reopened as the Gourmet Kitchen.

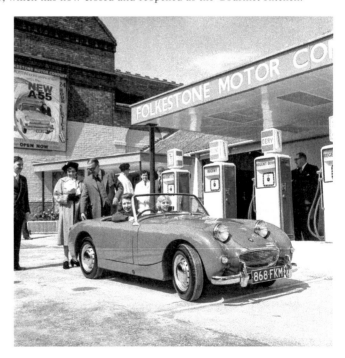

Folkestone Motor Company petrol station was at Nos 6, 8 and 10 Bouverie Road. This photograph, with the Austin Healey Sprite on the forecourt, was taken on 10 April 1959. At the time of writing the site is occupied by Halfords.

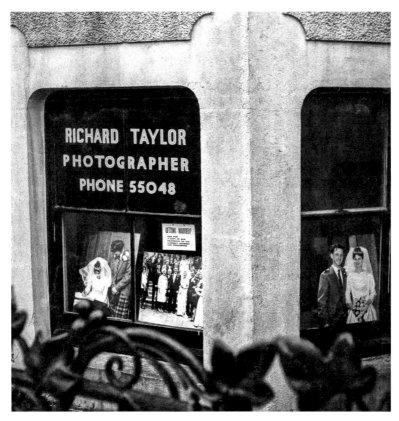

Photographer Richard Taylor, No. 3 Bouverie Road West, occupied these premises from 1961 to 1966, after which he moved to No. 7 Bouverie Road West, where he stayed until 1970. His main business was weddings, and from 1958 to 1992 the negative archive consists of some 7,000 jobs.

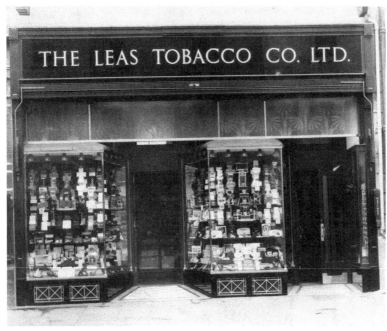

The Leas Tobacco Co. Ltd, wholesale and retail tobacconists at No. 73 Sandgate Road, were at these premises from *c.* 1920 to 1971. At the time of writing the shop is occupied by Pickwick Jewellers and Pawnbrokers.

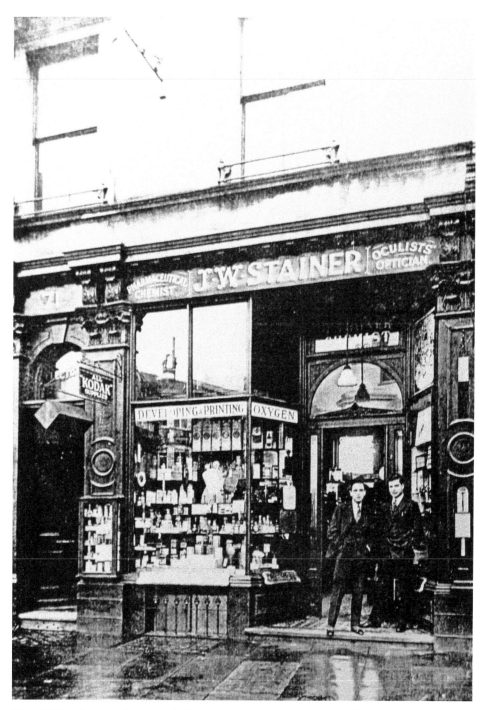

John William Stainer, pharmaceutical chemist at No. 59 Sandgate Road. Mr Stainer came from Hastings and bought these premises for £1,600 in 1961. This shop and its neighbour, No. 61, were newly constructed as shops with living quarters above. In around 1910 the street numbers were altered, this shop formerly having been No. 59 before became No. 71. John Ward Stainer continued to run the business until he retired in 1933, selling out to Savory & Moore.

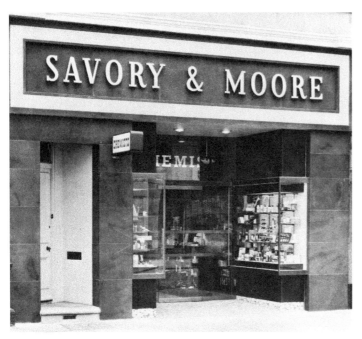

Savory & Moore Ltd, dispensing chemist and opticians at No. 71 Sandgate Road, were in business at these premises from 1933 to 1972, when they sold it to Lloyds Chemists. The shop, until fairly recently, was occupied by Triangles Café.

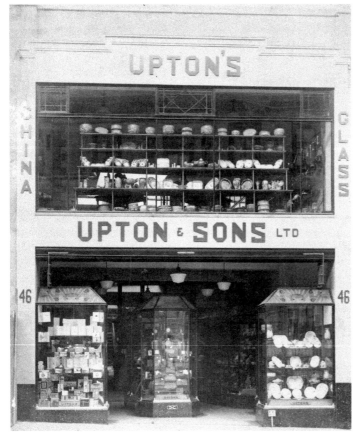

Upton Brothers Ltd had a shop in Tontine Street in 1895 and when the shops started moving into Sandgate Road they opened a store there. This branch, at No. 46 Sandgate Road, opened in 1931, selling china, glass, toys, fancy goods and stationary. It closed in 1963 and is currently the Hospice charity shop. My late mother, on leaving school in 1922, worked for Upton's in the stationary department one week before Christmas the shop stayed open until 9 o'clock and the staff had to work with no extra pay!

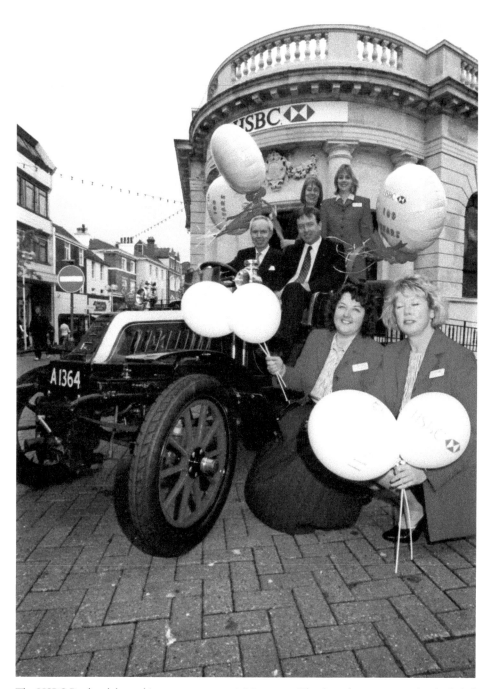

The HSBC Bank celebrated its centenary on 18 May 2000. The day of commemoration included a photographic exhibition, a turn-of-the-century car parked outside with manager Ben Sharp at the wheel, and balloons and gifts for children. The building was first occupied in 1895 by auctioneers, before the London City and Midland Bank opened. It expanded in the early 1920s, with the present façade designed by T. B. Whinney. In 1924 the bank became Midland Bank, which it remained until it was merged under the name HSBC (Hong Kong and Shanghai Banking Corporation).

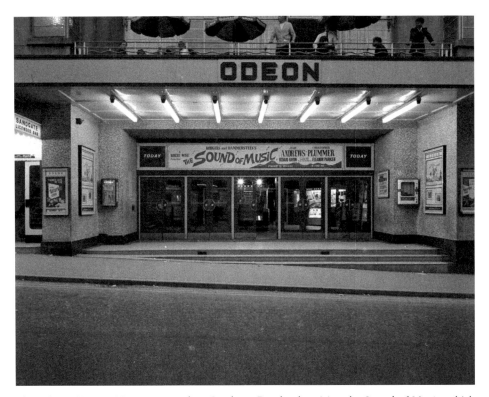

The Odeon Cinema, Nos 22, 24 and 26 Sandgate Road, advertising the *Sound of Music*, which is a 1965 American musical drama film produced and directed by Robert Wise and starring Julie Andrews and Christopher Plummer, with Richard Hayden and Eleanor Parker. The film is an adaptation of the 1959 stage musical of the same name composed by Richard Rodgers, with lyrics by Oscar Hammerstein.

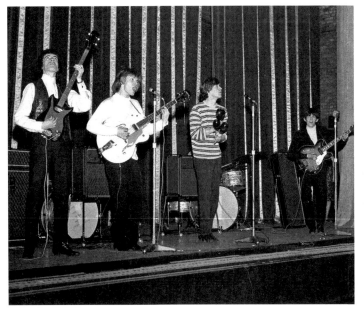

The Rolling Stones at the Odeon Cinema on 17 May 1964. They formed in London in 1962. The first line-up consisted of Brian Jones (guitar and harmonica), Mick Jagger (lead vocals), Keith Richards (guitar and backing vocals), Bill Wyman (bass), Charlie Watts (drums) and Ian Stewart (piano). Steward left in 1963.

Ann's Expresso
Bar, No. 33
Sandgate Road,
was over the top of
Home & Colonial
at No. 29 and
Edward Bairstow,
confectioners at
No. 31. The Ann's
Expresso Bar was
there from 1959,
becoming Patrice,
ladies hair stylist,
by 1962 and in
c. 1971 it became
the Elizabethan
Grill, run by Brian
and Pat Ward.

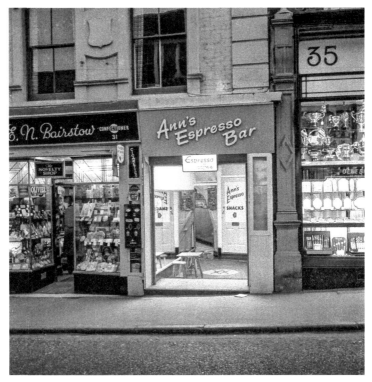

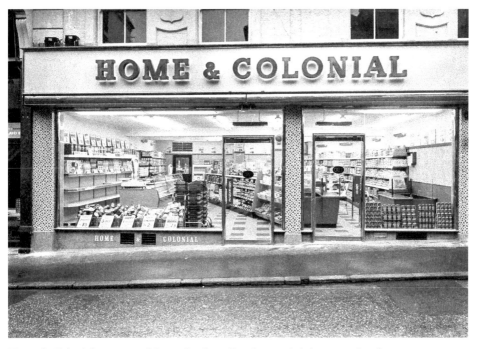

Home & Colonial, grocers at No. 29 Sandgate Road, occupied these premises from 1933 to 1967, after which it became Vye Sons Ltd, grocers. The entrance to Patrice, ladies hair stylist, can be seen on the above image.

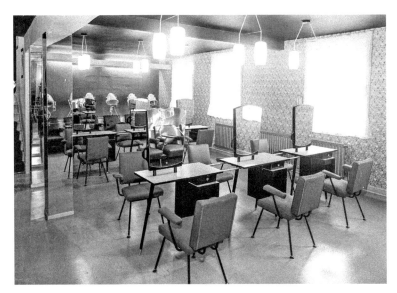

The interior of Patrice, which became the Elizabethan Grill, run by Ron and Pat Ward, who later owned Wards Hotel in Earls Avenue.

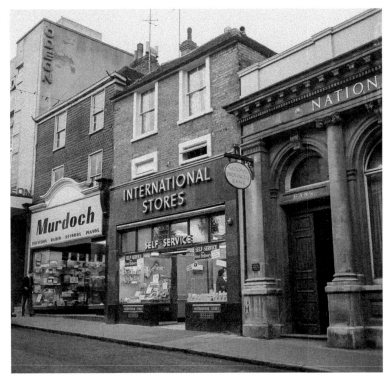

Here, from the right, are National Westminster Bank, formerly National Provincial Bank at No.16 Sandgate Road, now occupied by Waterstone's bookshop; International Stores, grocers and tea dealers at No. 18, now occupied by Grind 'n Bake coffee shop and baking; Murdoch TV dealers at No. 20, now occupied by Clarks shoe shop; and the Odeon Cinema at Nos 22, 24 and 26 Sandgate Road, now the site of Boots.

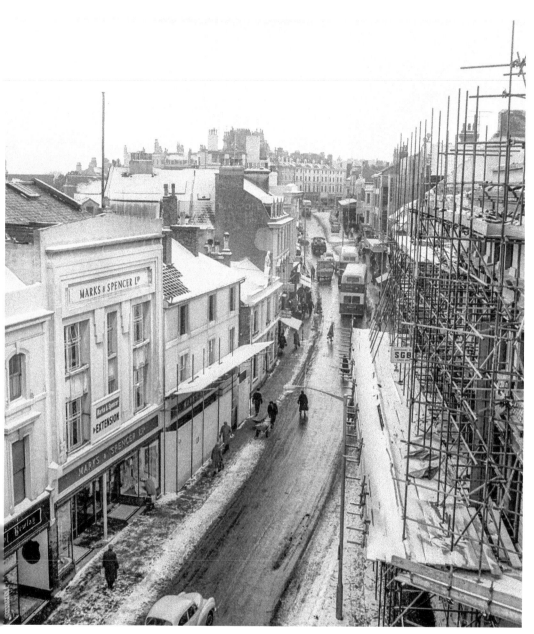

Marks & Spencer, Nos 9–17 Sandgate Road, are undergoing some rebuilding in February 1963. Marks & Spencer started in the High Street in 1912, moving to Sandgate Road in 1930. It was a very sad loss to the town when they closed in 2016. The premises are now occupied by Wilko. On the right scaffolding can be seen on the Queens Hotel in preparation to demolish it.

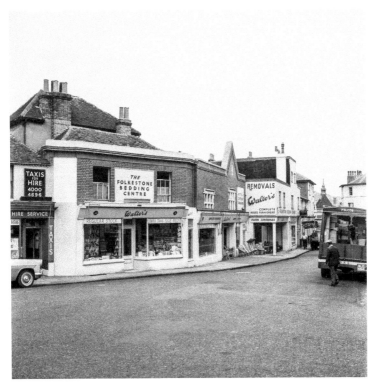

All these shops in Cheriton Road from the junction with Guildhall Street were demolished in 1972 to make way for a road built to bypass the town centre. To give you an idea of your bearings, Alford Bros Ltd, motorcycle shop, which is off the photo on the left-hand side, is now the first shop in Cheriton Road.

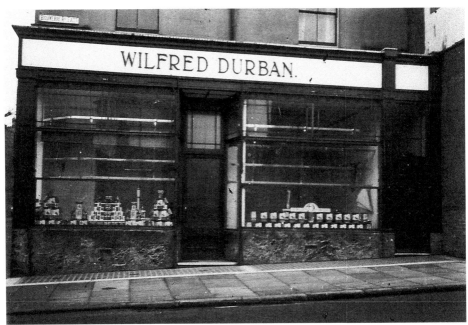

Wilfred Durban, butcher's at Nos 1 and 3 Bouverie Road East (corner of Gloucester Place). He started the business at these premises in 1928 and it was a butcher's shop trading under the same name until 1972. The shop was demolished around 1974, the road has been renamed, and is a continuation of Shellons Street.

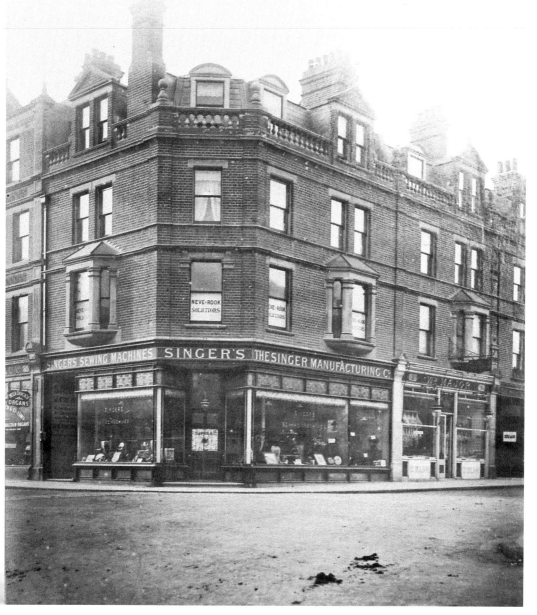

Singers Sewing Machine shop was on the corner of Guildhall Street and Cheriton Road. It was designed by architect Andrew Bromley and was built by local builder William Dunk. The photograph was taken by local photographer Arthur Burgess in 1898, soon after the building was completed. The premises are currently occupied by HEDZ the Alternative Gift Shop.

This terrace of shops Nos 1–7 in Shellons Street, formerly Cheriton Road, were also designed by architect Andrew Bromley and built by William Dunk at the same time as the corner shop. This photograph was taken on 7 March 2019.

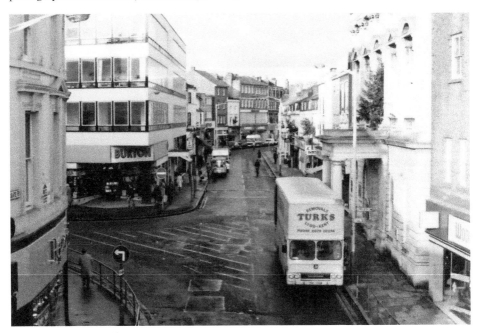

Guildhall Street at the junction with Sandgate Road. Montague Burton, men's tailors, moved into these premises in 1964, when their branch closed and Bonmarché took the shop over.

The *Folkestone Herald* offices at The Bayle moved to West Cliff Gardens in November 1984. The photograph was taken on 23 January 1987, just before the building was demolished. A complex of retirement flats, built for McCarthy & Stone, called 'Glendale' were constructed on the site in 1992. The starting price for a flat was £41,500.

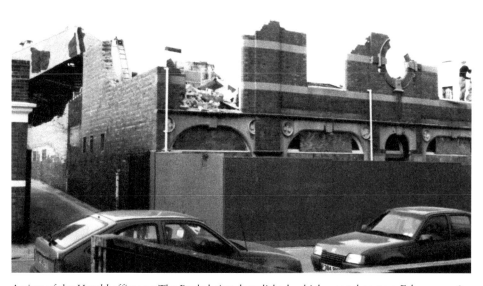

A view of the *Herald* offices on The Bayle being demolished, which was taken on 3 February 1989.

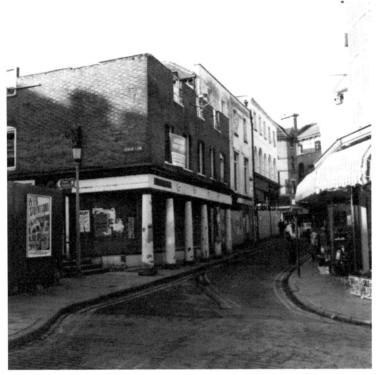

Plummer Roddis, house furnishers, occupied Nos 2 and 4 High Street (seen here) and Nos 16–22 in Rendezvous Street. The business closed in 1972 and the premises remained empty until they were demolished in 1984.

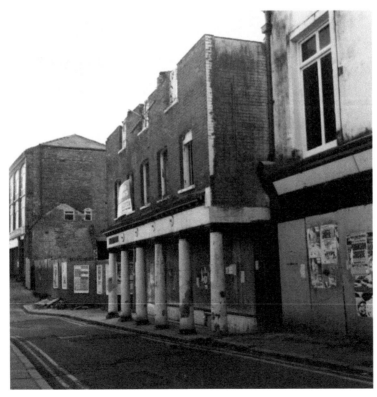

Another view of the empty Plummer Roddis building looking towards The Bayle, which was taken on 8 November 1982.

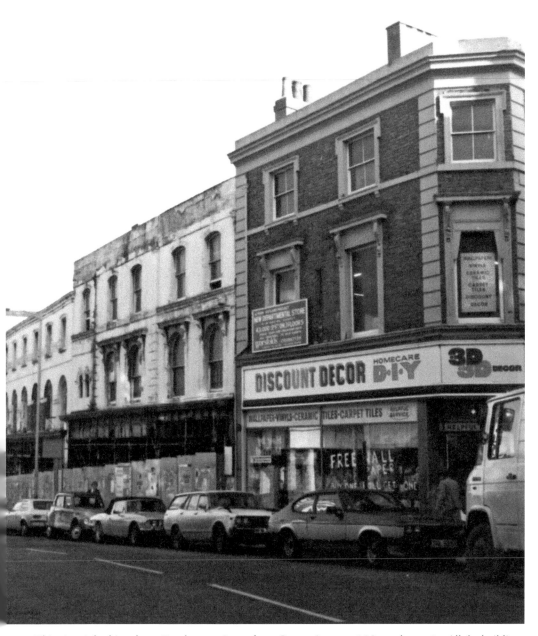

This view is looking down Rendezvous Street from George Lane on 8 November 1982. All the buildings past the Discount Décor DIY store are Plummer Roddis, house furniture, shops, from Nos 16 to 22 Rendezvous Street, which were all demolished in 1984.

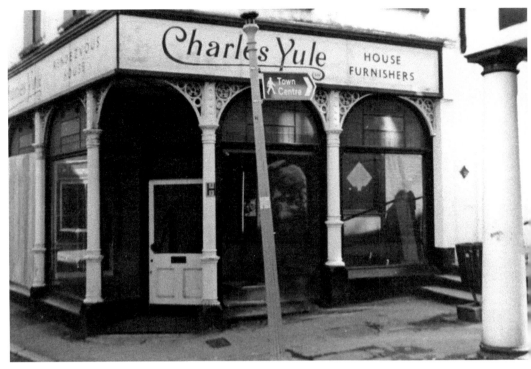

Charles Yule Ltd, house furnishers at No. 6 High Street on the corner of George Lane. Charles Yule occupied these premises from *c.* 1954 until 1972. The upstairs was occupied the Savoy Hotel from *c.* 1947 to *c.* 1954. The building was formerly the Folkestone Arms Hotel (*c.* 1717–1846). The premises were demolished in 1980.

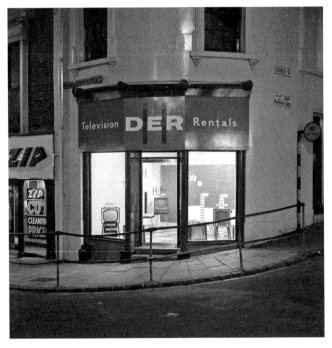

Domestic Electric Rentals Ltd (DER), No. 2 Rendezvous Street on the corner of Church Street, were at these premises from *c.* 1961. The shop had previously been occupied by F. W. Plaistow, tailors, from 1900 to 1906 when his son Arthur took the business over and ran it until 1959. The corner premises are on the site of Folkestone's Old Court Hall and in 1840 the town council decided it had no further use for the land and sold it for £44 on 7 October 1844. It was purchased by Revd Charles East Plater, who was the priest at the parish church. The shop and house were erected by Revd Plater and Mr Squire, currently occupied by Fella Gentlemen's Hairdressers.

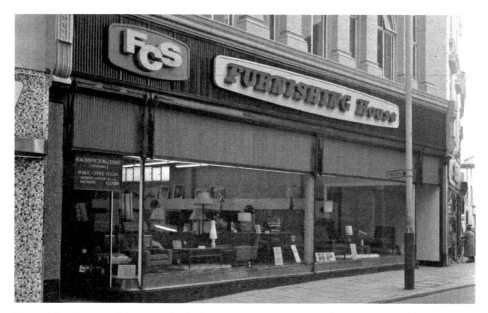

No. 28 Rendezvous Street was built for Montague Burtons, tailors, in 1928. They moved to Queens House, Sandgate Road, in 1964 (was occupied by Bonmarché). Folkestone Co-operative Society occupied this shop from around 1966 to some time after 1974 when the last Kelly's Street Directory was published. The first floor is the office of HM Inspector of Taxes. The shop is now occupied by Luben's Pizza restaurant.

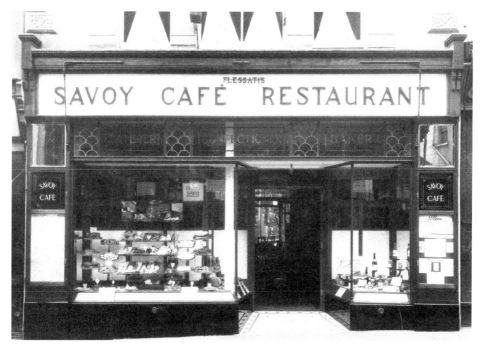

Flessati, Savoy Café, No. 28 Rendezvous Street, occupied this shop from 1930 to sometime between 1940 and 1947. The photograph was taken by Lambert Weston, a Folkestone photographer for F. J. Pike, shop fitters from Ramsgate, who installed the shopfront in 1930.

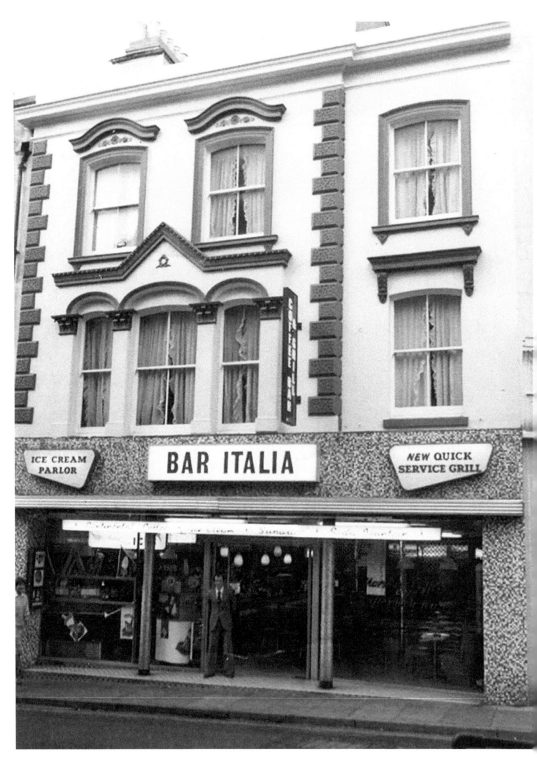

Bar Italia, Nos 26 and 28 Rendezvous Street, 1970s, was previously Morellis Expresso Bar from around 1958. Today it is the Salvation Army charity shop.

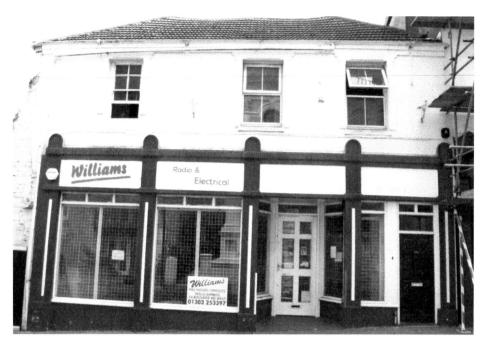

Williams Radio and Electrical, Nos 38 and 40 Rendezvous Street, on 2 June 2008. Williams moved from this shop to No. 28 Bouverie Road West, formerly Hall and King the West Cliff Pharmacy, opposite Tesco Express.

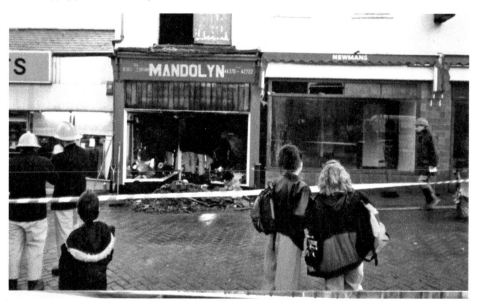

Nos 40 and 42 Rendezvous Street were destroyed by a fire at 4 a.m. on 27 January 1990. The fire started in Mandolyn fancy dress shop and spread to Newman's where a young couple living in the flat above had an escape after the arson attack. It took three hours for eight fire crews to put the blaze out. Two firemen needed treatment for cuts and flashburns when the front window blew out, and two firefighters were taken to the William Harvey Hospital when their fire appliance overturned as it raced to the blaze.

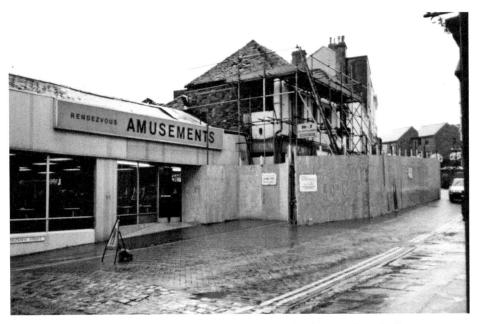

Nos 38, 40 and 42 Rendezvous Street on 31 January 1990. The shops are fenced off in preparation for demolition.

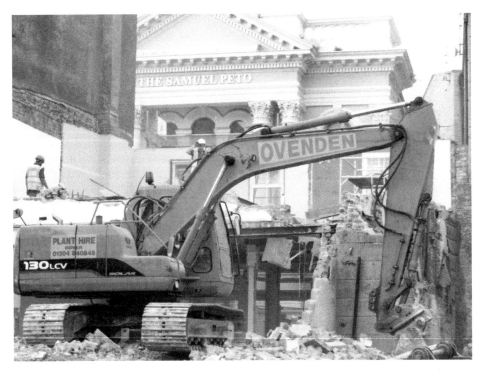

This is a rear view of the remains of Williams's electrical shop at No. 38 and 40 Rendezvous Street. Note The Samuel Peto (Wetherspoons), formerly the Baptist church, in the background. The site of Nos 38, 40 and 42 Rendezvous Street is now occupied by Rendezvous Family Amusements and a complex of flats called 'Riverside'.

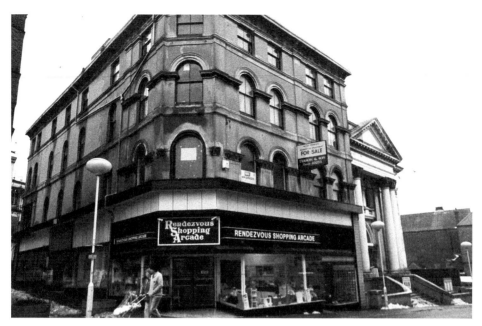

Entrepreneurs George and Anne Stirling bought this building, formerly White of Kent and previously occupied by Lewis and Hyland (draper's) and converted it into an arcade that could accommodate some fifty small shopping units. Rendezvous Shopping Arcade was opened by the mayor, Cllr Phillip Carter, in September 1984.

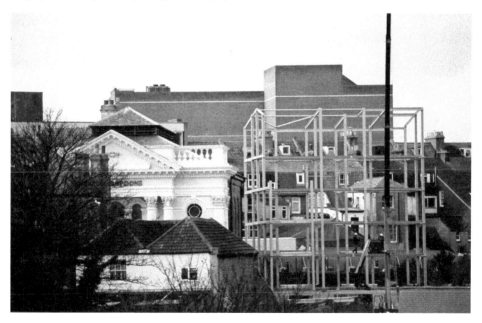

On the right-hand side of Wetherspoons is a complex of flats to be called 'Merchants Place', which are being constructed on 8 March 2004. The site had previously been occupied by shops, including Mr Wiltshire's motorcycle engineering business. They were all demolished in 1971 to make way for an open-air market, which opened on Tuesdays and Saturdays and had seventy-four stalls.

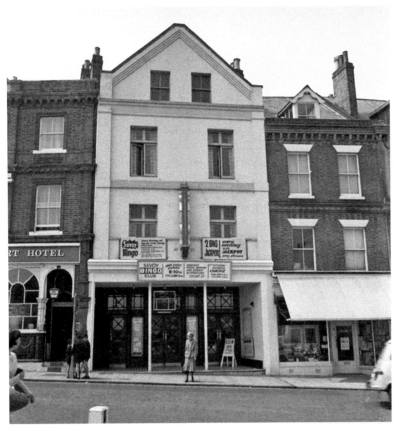

Star Cinemas, No. 1 Grace Hill, introduced part-time bingo at the Savoy cinema in October 1961. Formerly the Electric Theatre, which opened on Tuesday 3 May 1910, it was renamed 'Savoy' in 1928. It became the Metronome Concert Hall in September 1990, which only lasted four months. In 2016 the building was restored, with money from the Townscape Heritage Initiative Lottery Fund, into two flats and a theatre.

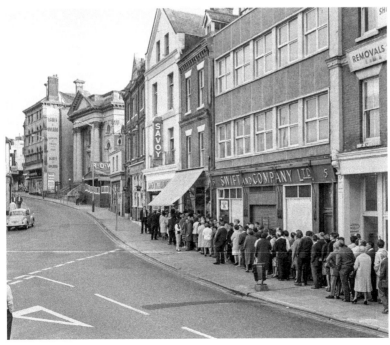

The people in this long queue are waiting to get into the Star Bingo and Social Club at No. 1 Grace Hill on the opening night in 1967.

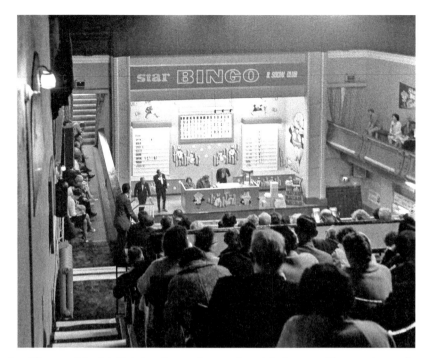

The Star Bingo and Social Club interior on the opening night in 1967. The people seen here are in the dress circle.

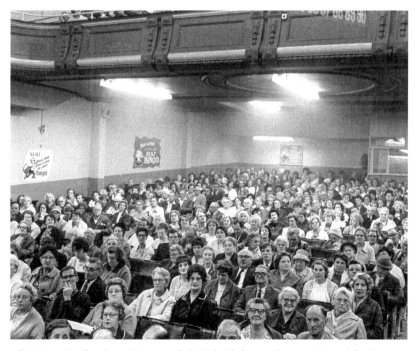

The auditorium in the Star Bingo and Social Club on the opening night in 1967. The photograph gives one an idea how popular bingo became. If you are a bingo fan you may well be in this photograph!

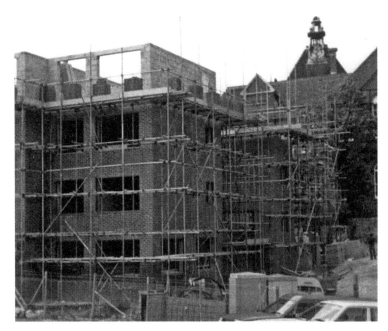

Grace Court, under construction in 1988, is a complex of sheltered housing consisting of twenty-six one-bedroom flats for up to thirty-three people, nineteen flats for single people and seven flats for couples. The opening ceremony was on Saturday 14 May 1988 and was led by Mr William J. McNeill, MBE, at the Church of St Mary and St Eanswythe. The Methodist church had previously occupied the site and was demolished in 1976.

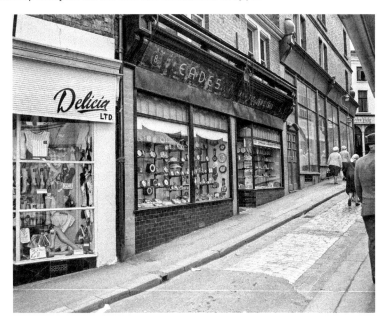

Edward Eade, watchmaker and jeweller, started at No. 8b High Street in *c.* 1914 and by 1934 he had expanded to 8a. The shop was sold in 1987 to Anthony Buckingham, at which time the proprietor was N. B. Railton. Mr Buckingham opened a stamp shop called Benhams. The photograph was taken in 1965. It is currently occupied by Wayne Reeves Art.

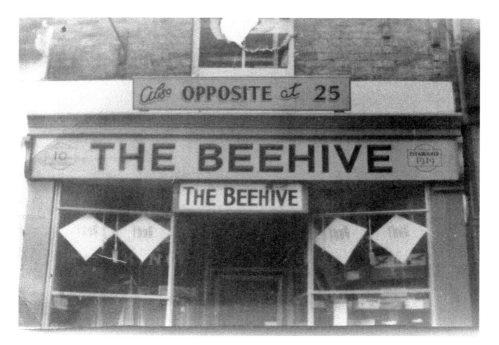

The Beehive was a toy dealers at No. 10 High Street, and were also opposite at No. 25 High Street. The business was established in 1919, but they traded from these two shops from 1936 to 1947. It is currently occupied by Mo Like Monkey.

BBC TV filming *Moon and Sun* in the High Street in September 1991. The main stars in the film are Millicent Martin (sitting under the brolly), who played Gladys Moon, and John Michie, who played her son, Trevor Moon.

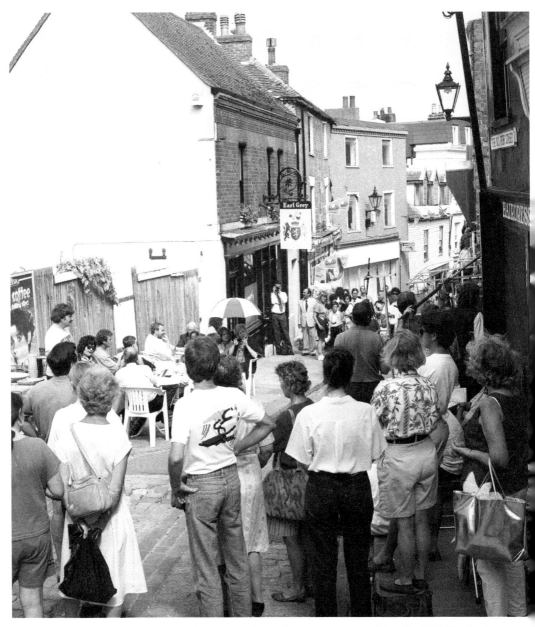

The crowds gathered here in the High Street in September 1991 are watching the BBC TV filming *Moon and Sun*.

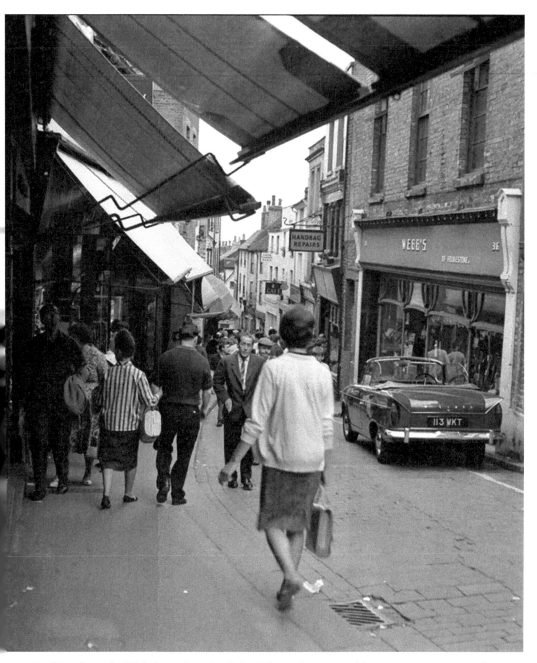

Looking down the High Street from just below The Bayle steps, Webb's, ironmongers occupied Nos 36 and 38 High Street and No. 41 opposite. Mr Webb retired in 1969 and the shops became the Folkestone Tool Centre.

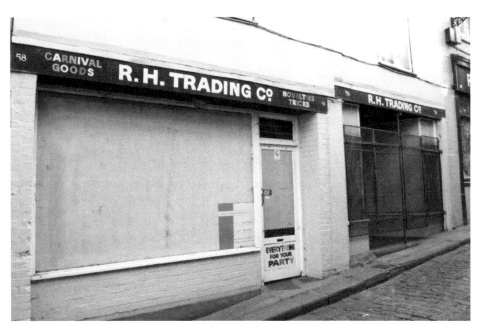

R. H. Trading Co. at Nos 56, 58 and No. 67 High Street. Mr Ramond A. Herit traded at these premises from *c.* 1969 to November 2006. He sold novelties, tricks, carnival goods, and also cut keys and did engraving. In 1971 the street was renamed The Old High Street, partly because the newly formed Traders Association became a spokesman for the restoration and preservation of the street.

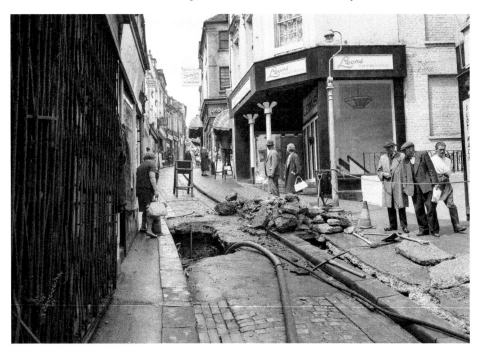

A view looking up the High Street in 1966 showing some subsidence where the sewer had collapsed. While some people look on, Brian Harris, who works at his father's fish shop at No. 54 High Street, can be seen wearing a white shirt on the right-hand side of the photograph.

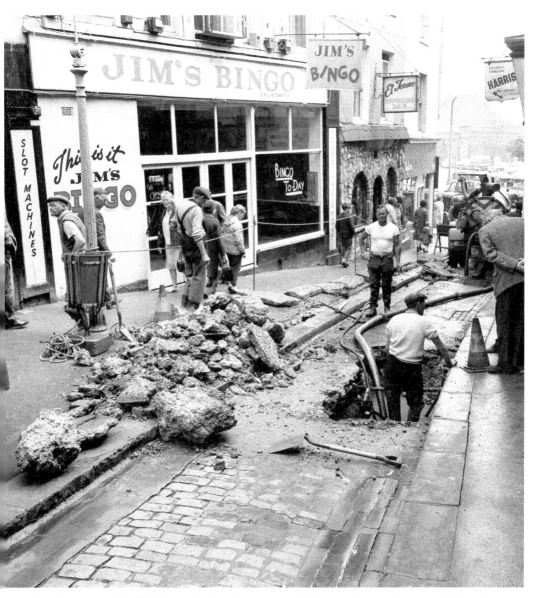

Another view of the High Street looking down towards Harbour Street after the subsidence in 1966. Also shown is the council's gullies sucker pumping out water.

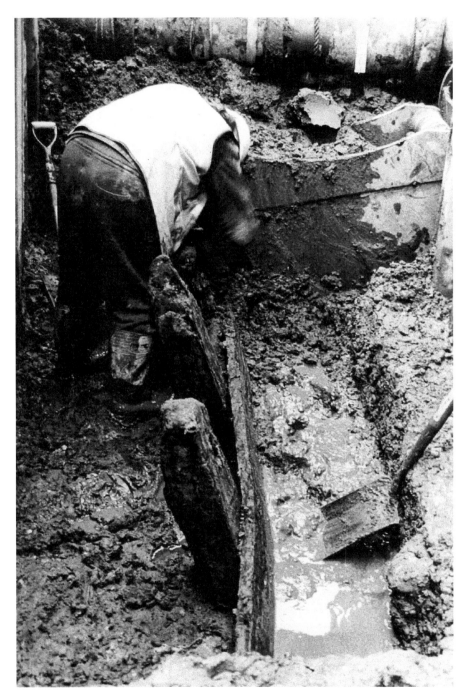

The timber piles and planking found running parallel to Old South Street. This almost certainly forms a revetment wall to South Street, with the harbour to one side and the hillside to the other (in the photograph the sea would be to the left). It was against this structure that ships would moor to unload. (The timbers were dated by their tree rings to between 1625 and 1650.) Archaeologists discovered the old harbour when Southern Water uncovered it during sewer works as part of a £120 million wastewater scheme in April 2000.

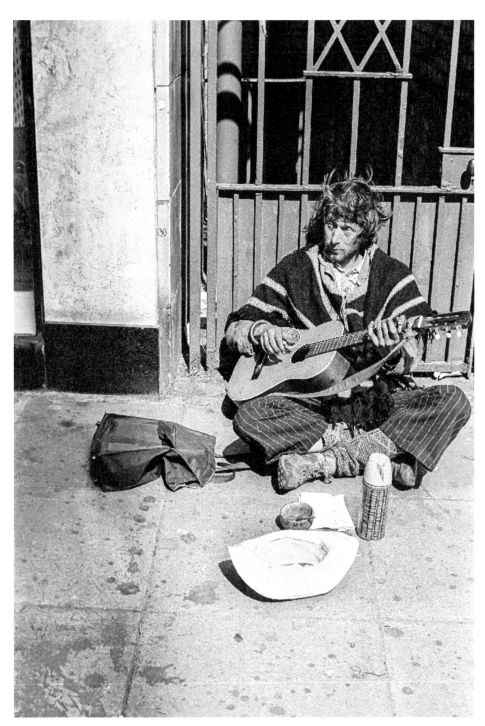

'Mad' Harry 'hippy' Harding could regularly be seen from morning to night in the shelter in Harbour Street, busking for money with his guitar. In 1979 his brother, Philip Harding, twenty-three years old, drowned in the mill pond. This saddened Harry and put him in an unstable mental condition. He died in 1992, aged forty-one.

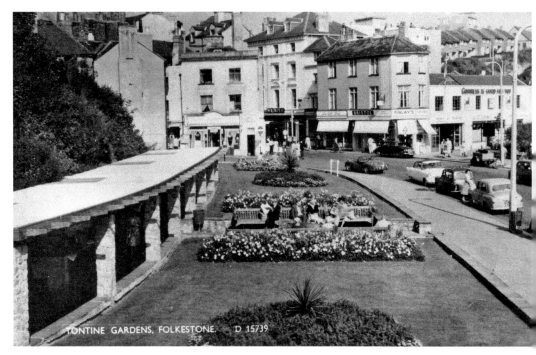

On the left-hand side is the shelter where 'Mad' Harry Harding could be seen regularly. The area changed with the Harbourside's £1.3 million facelift, which started in February 2000. These works were supported by Shepway Council, Kent County Council, the Single Regeneration Budget and European monies.

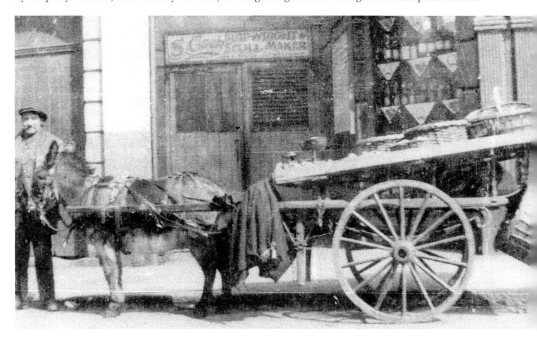

Stephen Cook, scull maker and shipwright, was at No. 19 Beach Street, from 1910 to 1914 and No. 7 Harbour Street (seen in the photograph) from 1914 to 1940. Mr Cook was coxswain of the Folkestone Lifeboat from 1897 until his retirement in 1919.

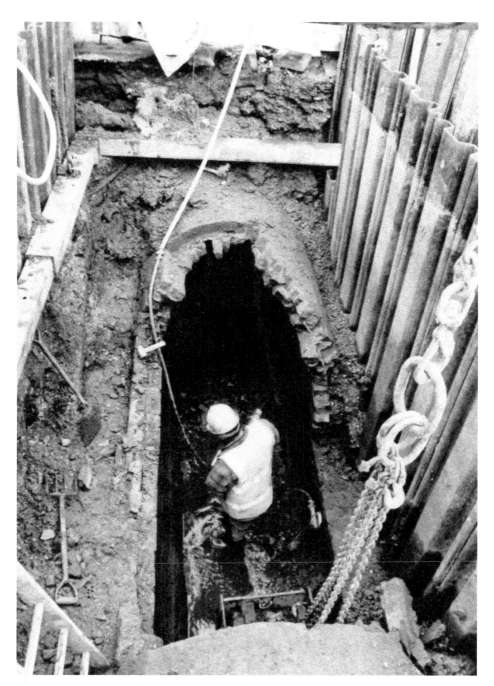

The Pent Stream culvert during the diversion of the stream in April 2000. It is oval in shape and built entirely of red stack bricks, with its base over 3 metres below the present road surface. It was constructed along the middle of the road during the building of Harbour Street and aligned from Tontine Street towards the present harbour. It replaced the open channel that the Pent Stream had followed from the base of the Folkestone hills to the harbour. During the cutting of the drain the Pent Stream was still flowing and caused the engineers many a headache. As it was constructed with Harbour Street, it must date to the mid-nineteenth century.

The Olympic torch came though Folkestone on 18 September 2012, seen here at the bottom of The Old High Street where it was handed over at the junction with Harbour Street at 14.26.

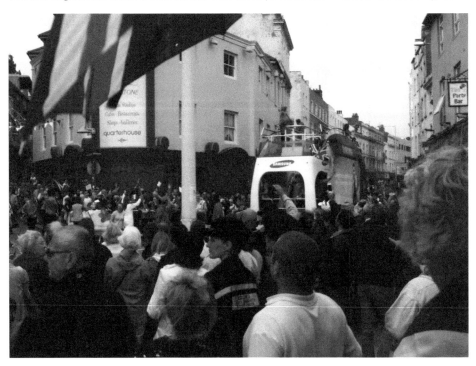

The Olympic torch has been handed over and is making its way along Tontine Street in front of the coach on 18 September 2012 at 14.26.

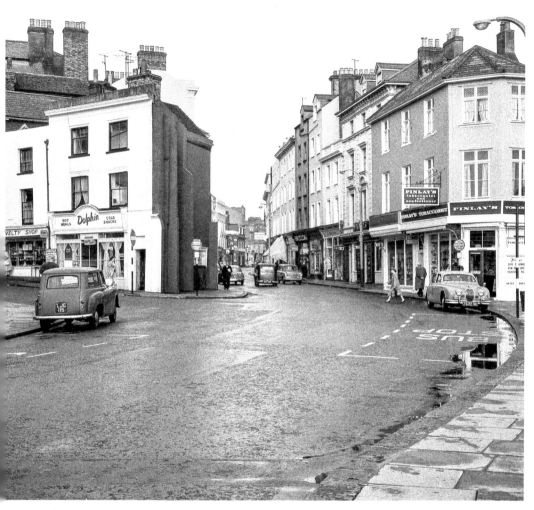

Harbour Street looking towards Tontine Street in September 1961. On the right-hand side is Finlay & Co. Ltd, tobacconists, at No. 2 Tontine Street, which was in business from 1939 to 1972, while on the left is the Dolphin Snack Bar at No. 79 High Street, which was in business from 1948 to 1961.

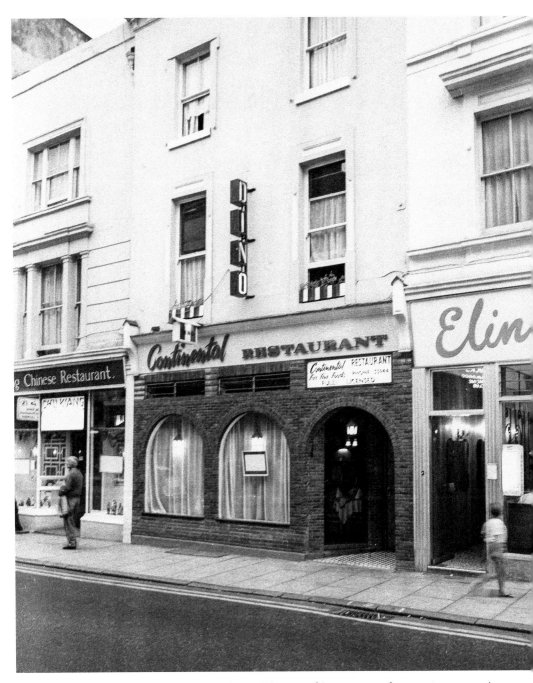

Continental Restaurant at No. 29 Tontine Street. Dino ran this restaurant from 1967 to sometime between 1974 and 1982, after which he moved to Dover. It's interesting to note that there is a restaurant each side of him. The photograph was taken in 1968.

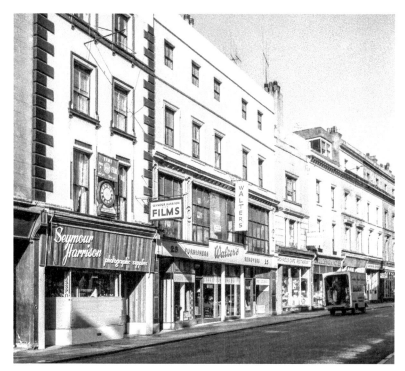

Seymour Harrison, No. 21 Tontine Street, was in business from 1919. His grandson Adrian Harrison (third generation) decided to move to Guildhall Street in 1996. He has now moved back to the site where the business started 100 years ago and is now open. This photograph was taken in 1959.

The interior of Dino's Italian restaurant, where I was a regular customer and was very friendly with the head waiter, Cesar Quintana Benitez, who left Dino's to buy Rossi's Boarding House, No. 4 Marine Parade (on the corner of Marine Terrace). He turned it into a hotel, calling it Gran Canaria. Cesar has now owned the hotel for forty years.

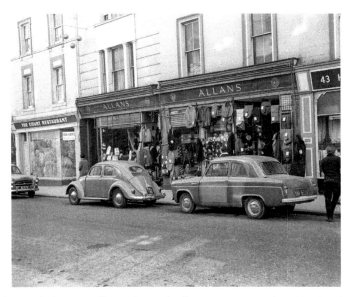

Allan's, outfitters, clothier, Jeweller and pawnbroker at Nos 39 and 41 Tontine Street, were in business from *c.* 1920 to 1965 and just at No. 39 until *c.* 1983. Allan's also sold second-hand tools that were in the basement, and when I was doing a carpenter and joiner's apprenticeship with local builder George Stone I would go to Allan's when I got paid Thursday after work. Sometimes I would get a bargain.

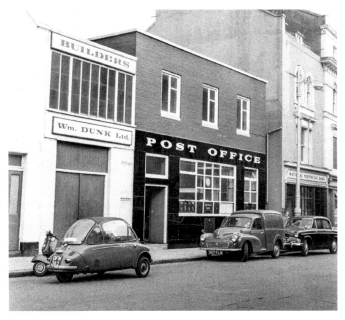

William Dunk Ltd., builders at Nos 50 and 52 Tontine Street and the sub post office, followed by the steps to St Michael's Street, were photograph here in 1964. Dunk's building has since been demolished and the site is occupied with a complex of flats called Merlin Court. The post office is now The Old Post Office, a creative agency. I can remember Dunk kept his ladders in this store and when they got out their fifty-rung pole ladder the traffic had to be stopped because it stretched right across the road!

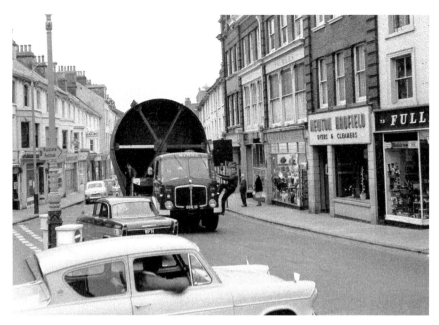

A heavy load trundling up Tontine Street on its way to Dungeness Power Station in 1965. It is the same load that can be seen on page 30 being unloaded from the ship.

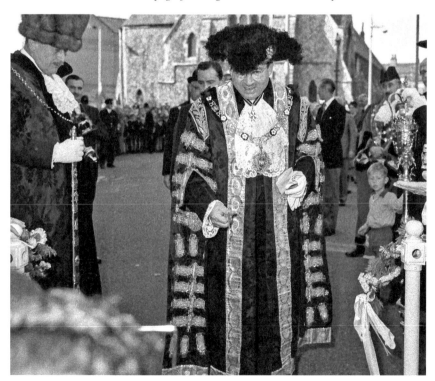

Alderman L. C. Aldridge J.P., the mayor of Folkestone, opens Tontine Street in 1961. The backdrop is the Congregational church, which was demolished in 1974. The Cube now occupies the site.

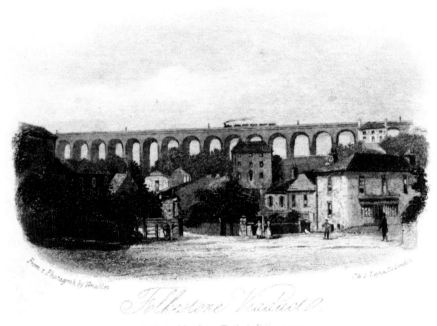

Folkestone Viaduct

Published by John English, Folkestone

An engraving from Dover Road looking into the Foord Valley, *c.* 1856. This is an early engraving drawn from a photograph by William Venables (1856–62) and published by John English (publisher of the *Folkestone Herald*). The large house below the train belonged to Mr Stace, who ran Bradstone Mill.

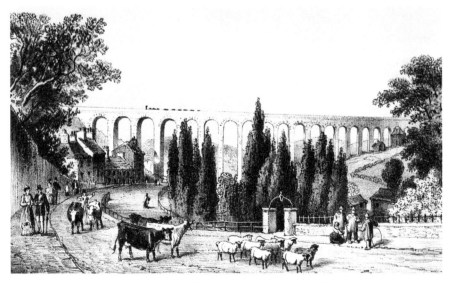

Extract from Nelson's guide: 'His route will carry him across grace hill, an eminence commanding a rich panoramic view; beneath the viaduct which, on nineteen noble arches nearly 100 feet in height, spans the Foord Valley; through the village of Foord; and past the Chalybeate Spring to the Crooked Oak.'

A photograph taken in 1968 of the opening of the new filling station with automatic petrol pumps for Peacocks (the main Ford dealers) in Foord Road. Peacocks site is now occupied by Home – Self Storage, and it's interesting to note the gas holder in the far distance side on the right-hand of the photograph.

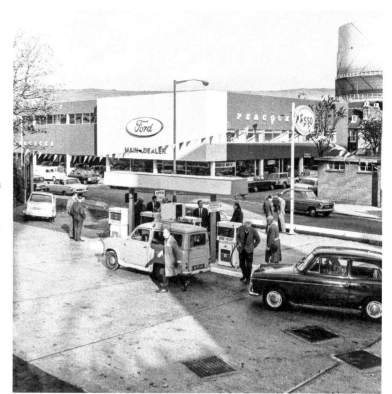

This image shows three houses in Pavilion Road, between Park Farm Road and Watkin Road, being demolished on 20 May 2002, making way for a complex of flats called Rosamund Court.

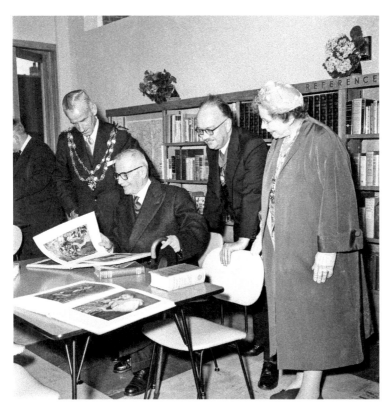

The New Branch Library, situated at the corner of Wood Avenue and Beatty Road, opened on 23 April 1960. The photograph is of the official opening by the mayor of Folkestone, Alderman Frederick W. Archer. This new library replaced a small shop premises in Sidney Street.

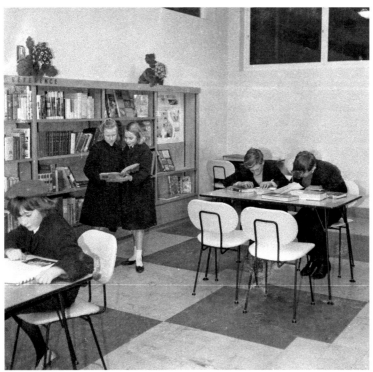

This photograph, taken in May 1960 of the new Wood Avenue Library, is of the children's section.

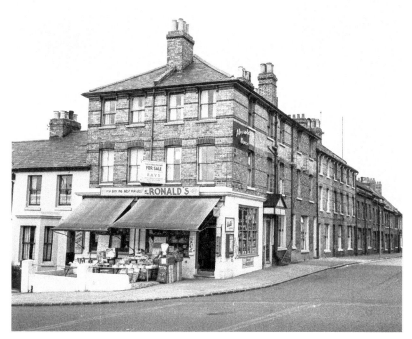

Ronald's, grocers at Nos 203 and 205 Dover Road, on the corner of Alexandra Street, was run by I. W. Huckstep in 1960. In 1893 it was the Railway Temperance Hotel, which was run by George Gray. It's interesting to note the name Alexandra House on the side wall. The building has now been converted into flats.

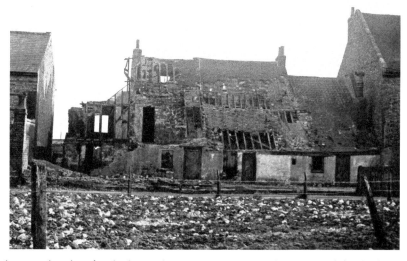

This photograph, taken for the borough engineer on 18 March 1929, is of the derelict cottages in Folly Road, which were declared uninhabitable, condemned and demolished. The current cottages in Folly Road were built in 1930.

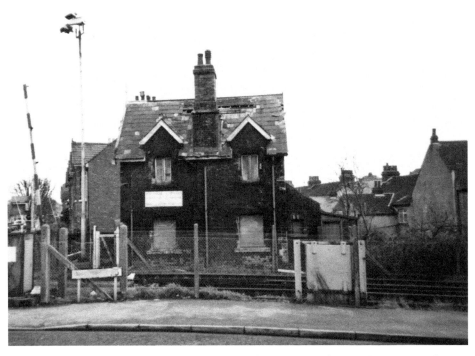

This photograph of the derelict Warren Road level crossing gatekeeper's house was taken on 29 December 2002, just before it was demolished.

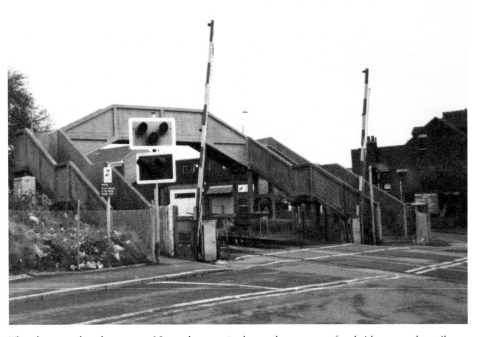

The photograph, taken on 29 November 1998, shows the concrete footbridge over the railway. It is a Southern Railway-style bridge built around 1946. It was demolished on 1 and 2 January 1999. Note the automatic barrier, which did away with the crossing gatekeeper.

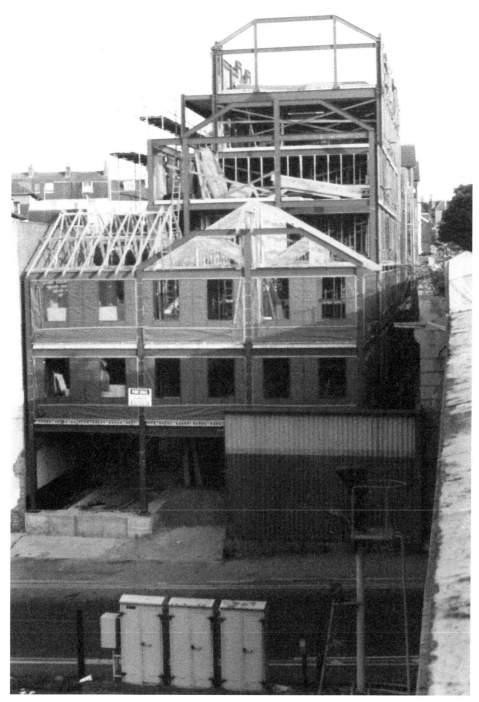

Flats under construction in Radnor Bridge Road and Tram Road are called East Cliff Heights.
The site was previously occupied by South Coast Engineers.

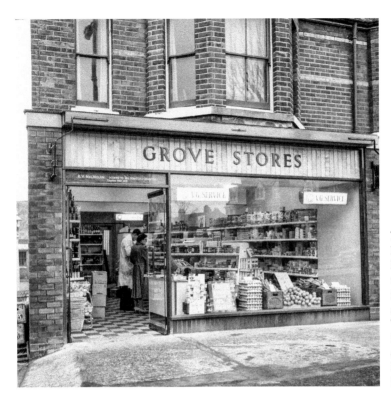

The Grove Road Stores, No. 4 Grove Terrace, Dover Road, occupied this grocers shop from *c*. 1961 to 1970, after which it became Tri Mart Self-Service Stores. Like so many corner shops it has now been converted into living accommodation.

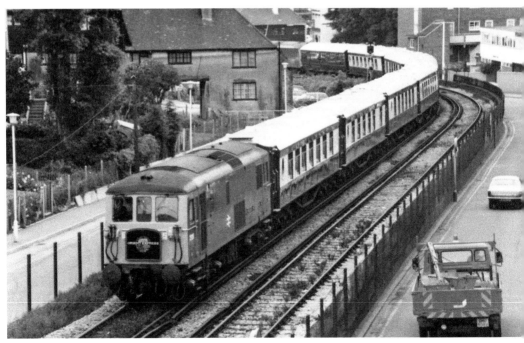

The Orient Express train, coming up the branch line from the Folkestone Harbour station in the mid-1980s, whose passengers would have crossed the Channel from Boulogne on a Sealink ferry – either *Hengist* or *Horsa*.

These properties, on the corner of Harvey Street and St Michael's Street, are about to be demolished to make way for a complex of flats called Saxon House. This photograph was taken from St Michael's Street on 25 October 2005.

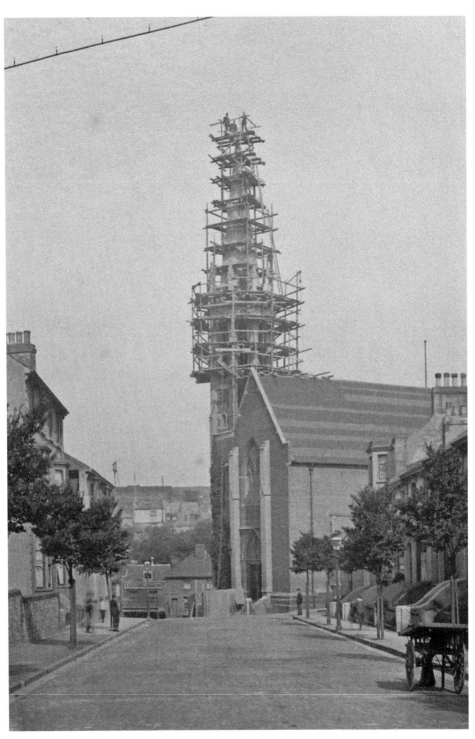

This photograph, taken by William Tiddy, photographer of St Michael's Church, was taken from St Michael's Street in August 1907 for the restoration of the tower and spire. The architect was C. H. Mileham from 1 Lincolns Fields, London, and the builder was William Dunk.

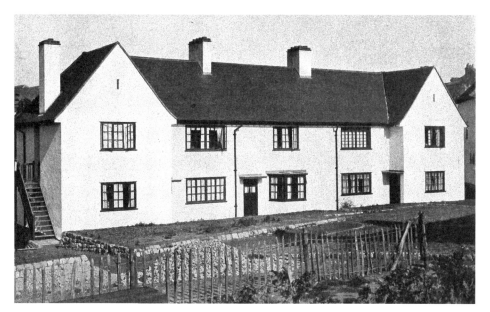

The Durlocks in the neighbourhood of the harbour was the site where Sir Philip Sassoon found a site for his housing scheme, on a vacant piece of land overlooking the harbour and railway line that runs at its foot. A Public Utility Society was formed under a government scheme, with a representative from local committee management. Messrs Culpin and Bowers were appointed architects and work started in mid-1919. The memorial stone was laid on 27 December 1919.

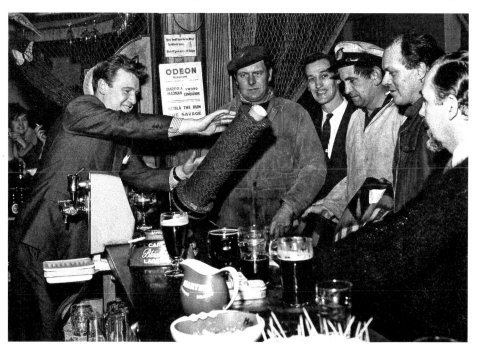

Actor Donald Houston pushes over a column of pennies for charity in the Oddfellows' Arms in February 1962. From left to right are Fred Featherbe, Charles Evans (landlord), Harry 'Tom Pepper' Featherbe, Danny Daniels and Donald Chaffy.

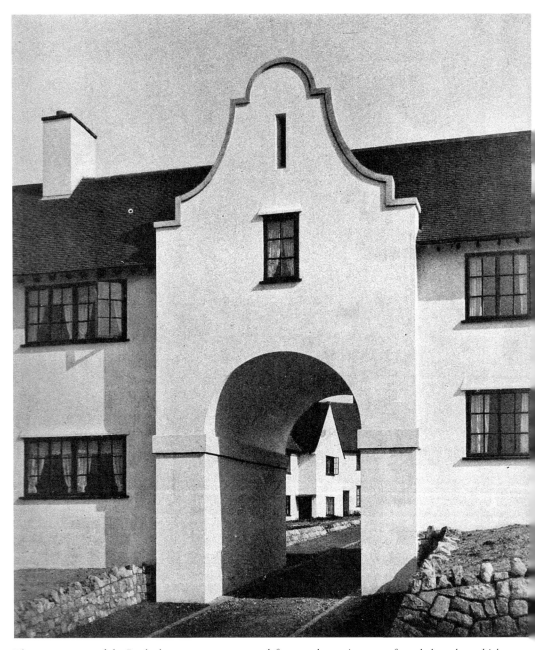

The average cost of the Durlocks cottages was around £750 each, a price some £250 below that which was declared at the time they were built to be the irreducible minimum. Tenants were waiting to move into both houses and flats as soon as they were ready for occupation. The rentals were 12s (70p) and 10s (50p) a week respectively.

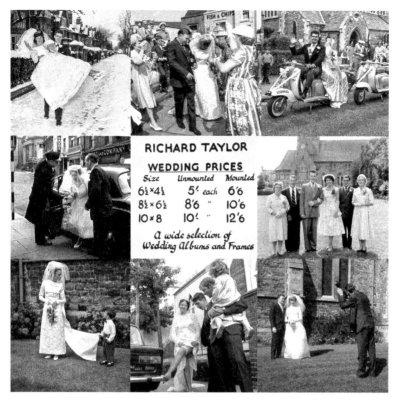

Above and below: This collage of wedding photographs is in memory of the late Richard Taylor and his wife, Pam. Taking wedding photographs was their main living during their thirty-four years in business.

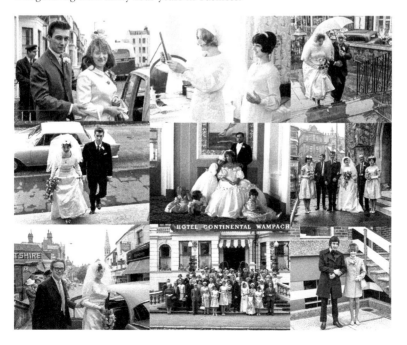

Acknowledgements

I would like to thank Richard Taylor from 'Nik & Trick' for allowing me the use of images from his late father's 7,000 negatives which Richard scanned for me. Without them the book would not have been possible. Secondly, I would like to thank Frank Bond for proofreading and the following people for allowing me to use their images: David Banks, Bob Reed, John Gale, Pat Senior, Steve Popple and Cy Miller.